Painting Portraits of Homes
in Pen, Ink & Watercolor

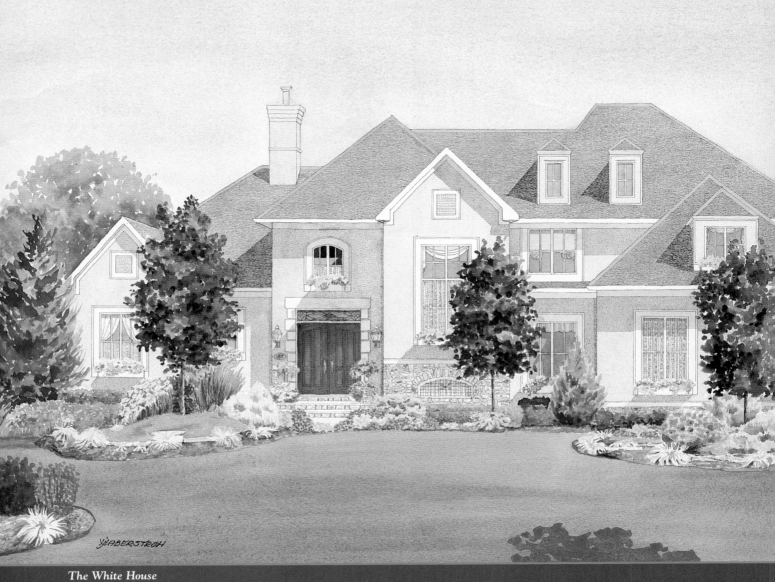

The White House
40″ × 60″ (102cm × 152cm)
watercolor and ink
on Crescent illustration board

PAINTING
Portraits
of Homes
in Pen, Ink &
Watercolor

Helen J. Haberstroh

NORTH LIGHT BOOKS
CINCINNATI, OHIO
www.nlbooks.com

ABOUT THE AUTHOR

Helen Haberstroh's parents recognized her natural gift early, keeping her well supplied with paper, pencils and a place to draw. Informal lessons from a retired art teacher taught her to see linear perspective in receding telephone poles and railroad ties. She studied a commercial art home-correspondence course for the three summers of her junior high school years, focusing on the elements of design around a single point of interest. It was through this course she was introduced to pen and ink.

Helen earned her Bachelor of Arts degree from Connecticut College, New London, Connecticut, as an art history major. She excelled in linear perspective, struggled fiercely with life drawing and took a smattering of other introductory studio art courses.

Being a wife, mother of three and frenetic volunteer helped Helen develop the discipline for time and financial management. One two-week period annually she designs and produces her own Christmas cards.

During her three years as a widow, Helen gained formal business exposure as project coordinator for a large company in Kansas City, Missouri. Today she enjoys marriage, and family as well as being owner/proprietor of Homes by Helen, which she started in 1984 in Cincinnati, Ohio.

New and repeat clients of Homes by Helen willingly wait eighteen months from connection to finished house portrait. Helen's reputation following over eight hundred commissioned house portraits and yearly exposure at art shows creates a refreshing backlog of assignments that spills into each new year.

Easily half of Helen's total art business time is spent developing new drawings in pen and ink with watercolor. She also maintains an inventory of over one hundred local and foreign scenes for sale by mail order, at art shows and in two galleries.

DEDICATION

This book is dedicated to my dear husband, Dick, without whom this new career would never have grown to its current dimensions. He has been my conscientious accountant, a sturdy partner hauling endless inventory to art shows for display and sale, talented picture framer and the best encourager through words and action I have ever known.

ACKNOWLEDGMENTS

My heartfelt thanks go to Pam Wissman and Nancy Pfister Lytle, tactful and helpful editors. Thanks, too, to all of those trusting clients who have challenged me to draw their homes, many of which are fondly remembered by example in this book. I am especially grateful to my now-deceased parents who nurtured this God-given talent throughout my childhood and taught me by example that serving others is worthwhile and may even yield a delicious satisfaction.

Painting Portraits of Homes in Pen, Ink & Watercolor. Copyright © 2000 by Helen J. Haberstroh. Manufactured in China. All rights reserved. No part of this book may be reproduced in any form or by any electronic or mechanical means including information storage and retrieval systems without permission in writing from the publisher, except by a reviewer, who may quote brief passages in a review. Published by North Light Books, an imprint of F&W Publications, Inc., 1507 Dana Avenue, Cincinnati, Ohio 45207. (800) 289-0963. First edition.

Other fine North Light Books are available from your local bookstore, art supply store or direct from the publisher.

04 03 02 01 00 5 4 3 2 1

Library of Congress Cataloging-in-Publication Data

Haberstroh, Helen J.
 Painting portraits of homes in pen, ink & watercolor / by Helen J. Haberstroh.
 p. cm.
 Includes index.
 ISBN 0-89134-954-5
 1. Dwellings in art. 2. Art—Technique. I. Title.

N8217.D94 H33 2000
751.42′244—dc21 99-045610
 CIP

Edited by Pamela Wissman and Nancy Pfister Lytle
Production edited by Nancy Pfister Lytle
Designed by Wendy Dunning
Cover designed by Brian Roeth
Cover illustrations by Helen J. Haberstroh
Production coordinated by John Peavler

TABLE *of* *Contents*

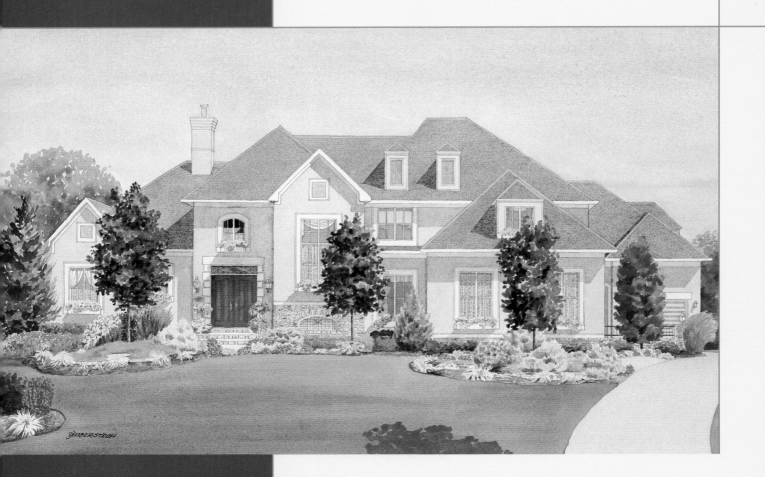

370

HABERSTRON

INTRODUCTION

A woman said, "And I'll pay you!" for a pen-and-ink drawing of the home her late husband had designed. In that electrifying moment, my hobby turned into a new career.

This book will help you learn to draw and paint house portraits as well, a satisfying outlet for your artistic talent and a way to pick up more than a little spending money. Anyone who really enjoys drawing can learn the fundamentals of perspective, a key element in the credible rendering of buildings. Your personal perseverance in following the step-by-step demonstrations of drawing and painting in this book will help launch your own style. Training your eye to catch details, examples of which can be found in chapter 5, will enable you to create a much-appreciated and unique custom house portrait.

The marketing and advertising tips suggested will help you increase your opportunities for new assignments, thus building your confidence and satisfaction in this hobby-turned-business.

While notecards and prints are natural extensions of the original work, vacation and local scenes captured in a sketchbook diary can be a source of income when displayed as prints at art shows. Ways to make fine lithographed prints of your originals are described in chapter 7.

Even if earning money is not your immediate goal, know that an original drawing of a home packs more meaning as a gift than anything you could buy. Your time with a minimum of expense will be the primary ingredient, and you will savor the obvious pleasure the gift evokes.

The White House
40″ × 60″ (102cm × 152cm)
watercolor and ink on
Crescent illustration board

IMPORTANT SUPPLIES AND HOW TO USE THEM

Transforming blank pieces of paper into mementos for particular people still elicits a miraculous feeling for me when I realize the gift nature has given me to draw and paint. However, the glow fades fast when poor-quality tools and materials frustrate the best intentions of the artist. Such an undertaking is labor intensive—it deserves the best paper, pen, ink, watercolors and brushes.

I would rather have a few high-quality brushes than an armload of every size of inferior ones. The tactile and visual stimulation of good paper, as well as the smooth performance of ink from the pen and paint from the brush, enhances the process of drawing and painting.

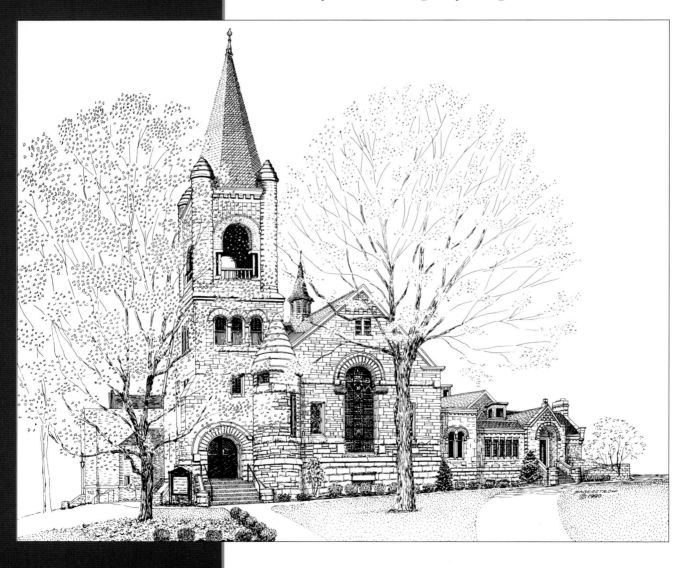

TOOLS OF THE TRADE

35mm Camera and Film

Use this for taking all your reference photos. I use 200 ASA film on sunny days. If the season has prolonged gray days, 400 ASA film will give clear pictures. A twenty-four frame roll is enough to capture the range of views needed. You can have it developed overnight at your local supermarket. Close-ups of front doors, shutters, windows, lights and landscaping are as critical as one photograph of the whole house. Try using different camera settings to ensure you capture the proper light.

> **HELPFUL HINT**
> *for Storing Film*
>
> Always keep film in the refrigerator to keep it fresh. Allow an hour for it to come to room temperature in its canister before using.

Polaroid 600 Camera and Film

This optional piece of equipment is for emergency use

- when you need a house portrait right now.
- when landscaping details are unclear in your 35mm photograph.
- when you need a single picture of current flowers in bloom.

You can also enlarge your photo on a photocopier to the scale you want as an additional reference tool. Keep in mind, though, that copiers distort the image to some degree.

Ballpoint Pen

If you did not compose your picture through the viewfinder when you took the photo, use a ballpoint pen to draw a framing rectangle on your photo. You can press this pen hard, scraping off a dark portion of the photo to produce a line you could not otherwise see.

1½″ × 2″ Pad of Sticky Notes

Sticky notes are excellent for marking the client's photo with the rectangle that frames the picture. They peel off easily when you finish, leaving the photo unmarked. You can also apply them to the back of a photo if you need to extend a roofline or peak cut off by the camera's viewfinder or trees.

1″ Drafting Tape

Drafting tape is not your common hardware store masking tape, which will tear photos when you try to remove it. Designed for temporary use, drafting tape will peel off neatly, leaving the photo intact. Take care, however, to avoid keeping the tape on too long or in sunlight or heat. The tape can leave a gummy residue on your photo.

Magnifying Glass With Handle

This helps you see tiny details in the photo that are important for customizing your house portrait. Another alternative is to have the photo of the entire house enlarged, but the magnifying glass will still come in handy. Remember: All the information you need for your painting is in your photos, so use the magnifying glass like a detective would to solve those hard-to-see details.

Drawing Board

A portable drawing board provides a firm vertical edge for maneuvering a T-square. A good size is 18″ × 24″ (46cm × 61cm) made of wood and about ½″ (1cm) thick. Its portability allows safe storage of your precious work in progress when other pursuits demand your time. It is also useful for you to have some means to tilt the board at a slight angle as you work.

> **HELPFUL HINT**
> *for Finding Drafting Supplies*
>
> You can more easily find several tools—such as circle templates, plastic triangles, engineer's rulers and drafting tape—in graphics or office supply stores, rather than art or paint supply stores. They can also be found in art supply catalogs.

Paper for Pen and Ink

Two-ply plate (smooth), acid-free bristol paper gives the best possible surface for a house portrait drawn exclusively with pen and ink. With a plate finish, fine ink lines stay crisp, and you can make erasures without seriously damaging the paper—or your ego. Acid free means that the paper is less likely to self-destruct over time.

Engineer's Ruler

This type of ruler has a minimum of four scales: 10, 30, 40 and 50. I use my pocket model, which measures 6¾″ (17cm), to scale a photograph's small dimensions into inches for the initial drawing, as well as to divide such critical spaces as windows and siding.

If, for instance, on your 30 scale, the measurement of your photo rectangle reads 8 high and 12 wide, your drawing will be 8″ (20cm) high and 12″ (30cm) wide. Measure each segment of your house drawing the same way. Often, the ideal measurement for the house portrait is a 40 scale divided by two. In this case, when the 40 scale on the photo measures 12 high and 18 wide, the house portrait will be enclosed in a 6″ × 9″ (15cm × 23cm) rectangle. All other 40 scale measurements of the house in the photo will translate to inches divided by two, or half of the 40 scale reading.

12″ Steel, Cork-Backed Ruler With Centimeter Markings

This will stay put on a slanted board. The markings are clear and accurate. They give both inches and centimeters from which to enlarge the drawing from a photograph.

T-Square

Placed firmly against the drawing board, the T-square moves up and down against one side of the drawing board to guide the drawing of reliably horizontal and, with a drafting triangle, vertical lines. Be sure the T-square is flush against your drawing board or table.

Transparent Plastic Triangle With 90° Angle

When used with the T-square, a transparent drafting triangle gives you the means to produce precise vertical lines and to see earlier drawn lines for reasonable placement of successive lines.

Hard Lead Pencil

I draw lightly with an Eberhard Faber 4H pencil, which makes a clean image, not easily smudged yet easily erased for corrections. The point stays sharp for long hours over the drawing board.

Graphite Eraser

This is critical, and it's not the one found on the end of the pencil. I use a soft white Mars plastic eraser, which erases only the pencil lines, leaving my paper surface intact. A noncrumbling kneaded eraser works well, too, until it gets dirty and leaves a mark. Regular pencil erasers can damage your paper and can mar an otherwise beautiful painting.

Lightweight Plastic Template With Several Sizes of Circles

This takes the guesswork out of arches, such as those found in fan windows, porch supports and decorative attic vents.

Pen and Ink

The Koh-I-Noor Rapidograph technical pen with a large-capacity cartridge and various nib (point) sizes for different line widths gives me reliability and speed. It produces precise, consistent ink lines. Using the waterproof black India ink designed for that pen gives longer use between cleanings, particularly if used daily. Use two nib sizes. Use a smaller size 3 × 0 (0.25mm) for most lines in every house portrait. Use a larger size 1 × 0 (0.50mm) for those occasional areas of solid black—window panes, shutters and wrought iron fencing. Store pens with the drawing point (nibs) turned up. The pens can easily clog otherwise.

> ### HELPFUL HINT
> *for Cleaning Pens*
>
> You can purchase cleaning solutions for pens, but a little household ammonia diluted with water is just as good. (Be very careful with the delicate nibs. They're expensive and easily damaged.)

Ink Erasers

Rectangular ink erasers sold as school student supplies get hard and may leave a mark without sufficient erasure. More efficient but of higher cost is an electric eraser with interchangeable eraser types. Care must be taken to lightly erase so your paper isn't damaged.

Watercolor Paper

Because of the irreversible nature of painting with watercolor over carefully drawn pen lines (allow ink to dry for a day or so), give yourself the best odds of successful completion. My choice for the house portrait finished with watercolor is 140-lb. (300gsm) cold-press, 100% rag (cotton) watercolor paper. Its bumpy surface, compared to the plate bristol, requires greater attention to your pen technique. However, the advantage of plying your brush on a luscious surface designed specifically for watercolor application far outweighs the occasional persnickety behavior of your pen. I use Arches watercolor paper in blocks of twenty sheets each, in 14″ × 20″ (36cm × 51cm) or 18″ × 24″ (46cm × 61cm) sizes. Similar to pads but bound on all four sides to eliminate prestretching, watercolor blocks have very heavy backing boards for support.

Watercolor Paints

Many standard watercolors sold in tubes by reputable manufacturers will hold their brilliance and hues indefinitely. However, some reds and greens that are basic to a student palette will fade or change color over time, even when not exposed to direct sunlight or when protected by special ultraviolet (UV) protective glass. It recently horrified me to see in one of my early paintings that my green grass had disappeared. Hooker's Green fades—believe me. *The Wilcox Guide to the Best Watercolor Paints* (Artways, Perth, Australia, 1991) changed my outlook on purchasing watercolors based on lightfastness ratings. Watercolors come in professional grade and student grade. Student-grade paints, such as Winsor & Newton Cotman paints, are good for beginning artists but don't have the longevity of professional lightfast paints.

> ### CAUTION
> *Don't Buy Student-Grade Paint*
>
> Beware of brand name paints that describe colors "for students" and are far less expensive than others advertised. They have noticeably less density of color and are subject to fading. Buy professional grade.

My Basic Palette Colors

Burnt Umber (reddish brown)
Cadmium Red
Cadmium Red Medium
Cadmium Red Deep
Cadmium Yellow
Cerulean Blue
French Ultramarine (blue)
Oxide of Chromium (green)
Payne's Gray (Mars Black +
 Ultramarine + Yellow Ochre)
Permanent Magenta (red)
Phthalo Green
Ultramarine Blue
Venetian Red
Yellow Ochre
Raw Umber

Distilled Water

I use distilled water, available in grocery stores, for diluting the watercolors and rinsing brushes. Tap water varies from place to place and time of year, often containing minerals and chemicals that may influence purity of color and longevity of brushes. I keep two containers of distilled water in the work area. One is for diluting the tube paint, and the other is for rinsing my brushes between color applications. After a painting session, I do wash brushes thoroughly with clear tap water and mild soap, with a final rinse in distilled water. If you do not have a sink nearby, you will need a pail for dumping dirty water.

Watercolor Palette With Cover or Plastic Wrap

The best watercolor palettes have a fair number of small compartments to hold pure paint from the tube and at least three large pans for mixing the paint with water. My first palette was about 12″ × 5″ (30cm × 13cm), made of white plastic, had twelve small compartments on the long edge and the rest of the space was divided into three large pans. I still use this palette along with a much larger one containing rectangular and round pans of various sizes. I find it useful to put the reds, browns and Payne's Gray in the first palette, and the greens, yellows and Ultramarine Blue in the larger palette. You can save most watercolors from day to day. You can even dilute them when they dry out completely. I save myself clean-up and mixing time by covering the palette with plastic wrap between painting sessions.

Medicine Dropper

You can lighten or darken colors gradually by using a medicine dropper to remove or add water. Sometimes I use it rather than a brush to add another color in a mix. The dropper needs rinsing immediately after using with colors so it stays clean for the next use.

Basic Brushes

High-quality brushes will hold large amounts of paint needed for a given space. Tapered bristles respond instantly when changing from a broad stroke to a narrow line.

Good brushes for beginners are a 1-inch (3cm) watercolor flat wash brush (for painting larger areas such as sky and grass) and nos. 10, 7, 3 and 9 rounds. Except for the 1-inch (3cm) wash brush, all of my brushes are red sable or Kolinsky sable, which hold the most paint per size and have a responsive resiliency. Many satisfactory brushes are a combination of synthetic and sable. Medium-size and small brushes with full bodies and excellent points are critical for painting trees and fine detail work. No. 0 and smaller brushes can be all synthetic for a good result on small details. I also use old brushes for mixing.

Masking Fluid

This keeps watercolors temporarily out of unwanted places. It has the consistency of rubber cement. After your paint is dry, remove the dry masking fluid with a kneaded eraser. Using masking fluid produces a harder edge around the painted area than leaving an area unpainted.

Paper Towels

These are essential in the watercolor process. I always place one sheet under my mixing palette to catch drips and to wipe a brush quickly. A second sheet within grabbing distance has saved more than one painting from disaster when paint has spattered, was too dark or even the wrong color.

Apron With Bib and Large Front Pocket

This covers and protects a wide variety of clothing needed for any given day and helps put you in the right frame of mind for working. The apron also helps keep others from interrupting you at a critical time, because it tells them of your intentions at the moment. It also serves to clean a smudgy eraser and provides space for a handkerchief or facial tissue for that unexpected sneeze.

Save With Art Supply Catalogs

Good brushes sold in art supply stores are easily accessible but expensive. Art supply catalogs, even with added shipping costs, offer more choices among manufacturers and charge about one-third less than retail. Check art magazine ads for suppliers.

Confession

I am in love with my high-quality brushes. They are extensions of my soul, reaching beyond arm and hand to transmit ideas to paper in a meaningful way. I briefly mourn the loss of each favorite when the bristles eventually lose their point, but I waste no time replacing it. Save old favorites for masking and lifting.

HOW TO TAKE GOOD PHOTOS OF HOMES

Your goal is to have an attractive and detailed photographic model for your house portrait. If you take your own photos, they will be more inclusive, likely to be more clear than what a client might give you, and you can get the exact view you think best. To get good photos, you must have a reliable camera, the right film and good lighting.

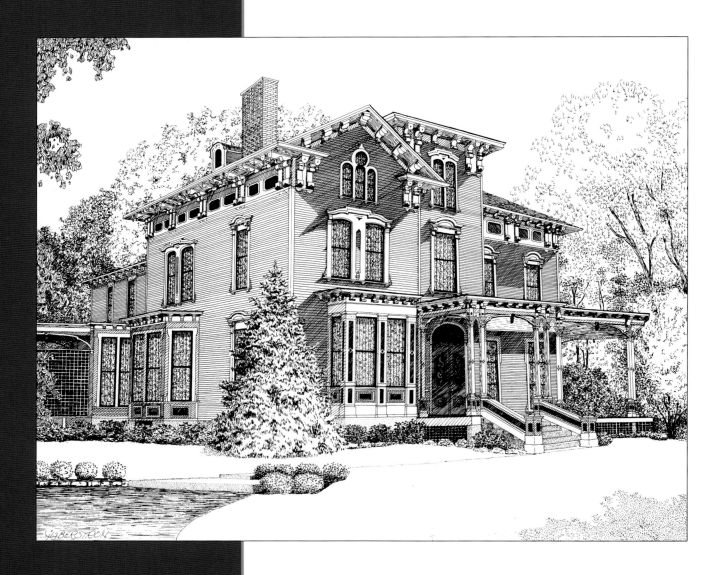

LET'S TAKE PICTURES

My 35mm camera is a good friend on this artistic journey. Its viewfinder frames my view instantly. Its photos answer all my major questions about construction and landscaping. Shooting enough photographs in one trip saves me travel time. If you do not know much about cameras, get a 35mm with automatic features. All you have to know is where to press the button and when to read the camera instruction manual. Use either 200 or 400 ASA 35mm film. 200 ASA is usually better for sunny days, while 400 ASA is better for cloudy days.

Ideal Conditions

The morning sun is shining (but not too brightly), you have loaded your 35mm camera with either 200 or 400 ASA 35mm film, and the owners know you are coming to take pictures. Freedom to roam all over their property without being assaulted by the pet dog helps you concentrate on the task of composing the picture, although there are other hazards.

Typical Conditions

Many of my commissioned works are surprise gifts for the home owners, so I must take photos when no one is there. Curious neighbors often sense a security risk or worry that the house is going on the market. Business card in hand, I try to coax that neighbor into a conspiracy of silence. One even advised me to call the local police department before planning to take pictures during an owner's absence.

Another time, on a secret mission, I deduced that the numberless house was that one between those other two and snapped nine or ten frames. When I had the photos developed, I felt strangely uneasy so I asked my client to describe her daughter's house. It was nothing like my pictures because I had jotted down the wrong house number. My motherly advice to you is to trust your instincts.

I take a minimum of three photos of the whole house. Other photos will be close-ups of all the details that make this home unique and your house portrait a custom work of art.

Using the Clients' Photo

What if you must use the clients' photo, such as one shot of a former first home, and they absolutely refuse to fund your trip halfway across the country? You will have to ask a lot of questions to clarify what you cannot see. It's worth the trouble. Besides, there is usually a nice story about those early years.

Whole view

Left side of house with landscaping

Right side of house with landscaping

Pick the Best Time for Good Lighting

Weather, time of day and season influence lighting. To see shadows clearly, take photos of an east-facing house in the morning or of a west-facing house in mid-afternoon. The best situation is to have the sun a bit above and behind you.

Time of year may influence how often you can count on sunshine and whether or not flowers are important to the picture. I try to take most of my photos in the summer months even if I cannot do the work until winter. If your homeowner takes enormous pride in gardening, ask about the blooms desired in the house portrait.

Choose the View

Years ago I featured the front view of a historic home as the essence of architecture in its day. A towering spruce tree flanked one side of the porch; a leaded glass window over the front door suggested tall ceilings inside. Shell shingles, vertical and horizontal siding framed the elegantly tall windows. As is true of the majority of my clients, these owners left the view to my discretion. I eagerly awaited their reaction to my finished house portrait. Surprise! My view was not their idea of home.

The best view, I learned, is to shoot the house at a slight angle so that more windows and living area are visible along with the front. The most attractive view shows most of the front and a little of the side. Real people live here and those rooms reflect a special chapter in their lives. Of course, it never hurts to consult with owners about the preferred view *before* putting pen to paper.

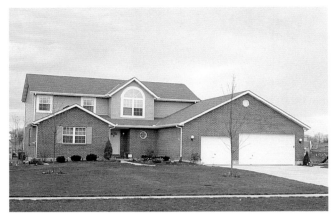

Best View
Take your picture to show two sides and the front door. The best view places the front door slightly to the upper right or left of the center of the picture. Show more of the front than the side. The garage is most distant from viewer.

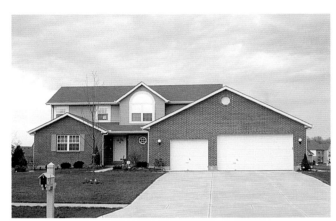

Okay View
Photograph just the front.

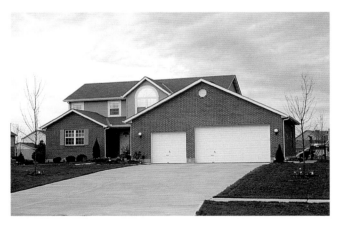

Worst View
I have lost the porch window and overwhelmed the second-floor space with garage doors.

Acceptable, but less interesting, is the straight-on view. Totally unacceptable for the custom house portrait is the dominance of an unimportant part of the structure, such as large garage doors. The owner does not care as much about the car collection behind those doors as he or she does about the home that shelters the family. If so, an automobile artist, probably not you, would be taking pictures of the garage with the doors open and a car in the driveway.

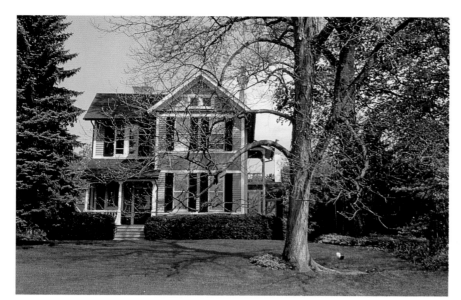

Most clients want this view

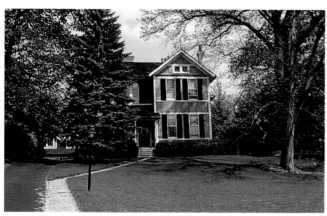

My idea of best view

HELPFUL HINTS
for Determining Good Lighting

If the sun is shining too brightly, cast shadow areas will contrast too much with sunny areas, and your photo will not capture details in the shadows. At noon the sun may glare over the roof. Your photo will show a dark silhouette of the house. Another situation arises when you have your pictures developed and several trees cast such intense shadows on bright siding that you lose details. You also do not want the angle of the sun to cast shadows that are too long or too short. A good solution is to shoot on a cloudy day using 400 ASA film.

Knowing the direction the house faces can help you determine what time of day is best to shoot it, based on where the sun is in relation to it. Northern exposure in the northern hemisphere can be good, because it never sees direct sunlight. Shadows are therefore more subtle than those caused by sunlight because they indicate structural overhangs rather than strong cast shadows.

House numbers in your city can give you clues about the direction a house faces. In Cincinnati, Ohio, I have noticed that even numbers usually face south or west and odd numbers face north or east. It can be different, though, on curving streets in new developments.

You may adjust the sun angle later in your drawing by lengthening or shortening shadows to make a more pleasing composition.

Let's say you have already made the trip at a too-sunny time. You might photograph just details, being careful not to aim any part of your picture at the sun. Plan to return to that site at a different time or on a cloudy day, using 400 ASA film, to capture the whole view clearly and plan your composition. You can also learn to use your camera better by setting exposures for the area you need detail in—for example, the house, not the sky.

Problem: Foreground trees block a good view of the house.

You cannot see where the roof ends, the location of the chimney or how the wing is attached.

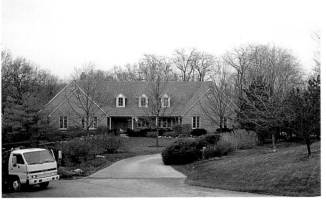

Solution: Take pictures when the trees do not have any leaves.

Shoot your photos in the fall after leaves have dropped or in spring as leaves are emerging. Note what kind of tree it is and fill in the leaves later.

Problem: A tree hides the front door.

Even when you follow the guidelines to position the door near the center and capture the angled view, a tree may be dead center, calling attention away from the house.

Solution: Photograph another view.

Move around the yard so that both door and tree show.

Problem: The roof does not appear in your photo.

If the roof of a house on a hill does not show in your camera's viewfinder, you will not see it in the developed photo. The house looks naked without a roof.

Solution: Take photos farther from the house, in addition to close-ups.

You need to know what type of roof it is, such as shingle, slate or metal. Photograph the chimney, too, because you should suggest it in your drawing.

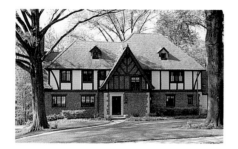

Problem: You cannot frame the entire house.

Large trees hide both ends of the house, no matter what views you try, or a long ranch-style house does not fit into one photo.

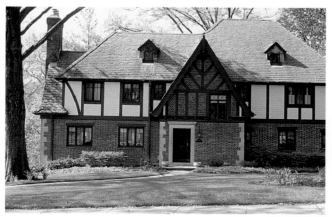

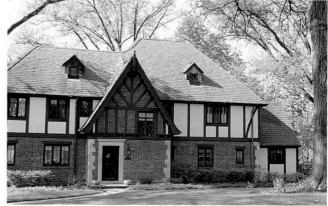

Solution:

Take two pictures, left and right, that reveal the ends of the house.

Make sure that each photo shows the center of the house, so you can connect the two views realistically in your house portrait. Move in a straight line left to right. Often you can tape two photos together to make a complete picture.

Photograph All the Details

Starting with the front door, move and snap your pictures left to right across the first floor. Then do the second floor and upward to the roof area. Photograph all close-ups suggested by the following checklist and others you see, unique to your house:

- Front door area: door handle, knocker, side windows, wreath, concrete goose, flower pot, family pet, etc.
- Light fixtures, including free-standing coach lamp
- House number location
- Porch railings
- Front steps and pillars
- Typical window: framing, decorative brick design, shutters, etc.

- Decorative window: leaded glass, stained glass, fan, etc.
- Bay window and supports
- Dormer
- Siding: aluminum or wood siding, bricks, random-design stone siding, brick or stone designs interrupting an otherwise plain wall or decorating the corners (called *quoins*), etc.
- Decorative eave supports and *dentils* (a series of small projecting rectangular blocks forming a molding)
- Roof pattern: slate, tile, vari-colored shingles, etc.
- Chimney, particularly if trees hide it in your best view
- Garage door showing panel

design
- Side structures: deck, fencing, etc.
- Landscape elements: trunk of foreground tree to capture texture, flower beds, decorative rocks, stone edging, etc.
- Sidewalk when it is close to the house and not easily seen in your camera's viewfinder

> **HELPFUL HINT**
> *for Capturing Details*
>
> You can capture several details in one photo. Turn your camera to get a vertical picture of landscaping, typical first floor windows and quoins.

Take Notes to Help You Later

Note whether the house faces north, east, south or west. Note the time of day you take the pictures.

Develop Your Film

As soon as possible after shooting your last frame, take your film to a grocery or drugstore that offers regular 24-hour service at no extra charge. Mark the order envelope:

• *Matte finish*. Otherwise you will automatically get a glossy finish that reflects light in annoying ways when you are trying to draw your house outlines.

• *Print all frames*. You can often squeeze two or three more frames from the roll than advertised.

• *3″ × 5″ regular size prints*. These show enough detail to give you different options when planning to draw your house portrait. Wallet sizes show limited detail. Enlargements larger than 3″ × 5″ cost more without any particular benefit, except that along with your magnifying glass, they may be easier on your eyes. Also, enlargements require you to pick your best shot and wait up to a week for developing.

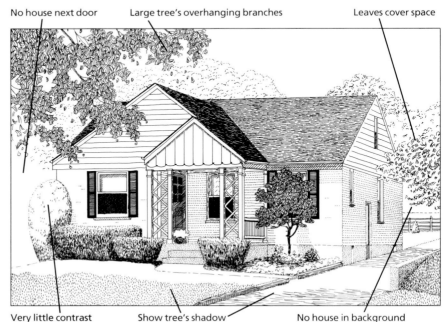

No house next door | Large tree's overhanging branches | Leaves cover space

Very little contrast | Show tree's shadow | No house in background

Problem: Surroundings are distracting.

A large tree trunk covers too much of a small house. Neighboring houses are distracting.

Correct Problems Later

Problems do occur when planning the best view of the home, such as large trees in the middle of the picture. Assuming that you have taken close-ups of all parts of the house, you can adjust your composition later when drawing.

Solution: Leave out distractions.

When drawing your house portrait, merely suggest the tree and leave out the neighboring houses.

HELPFUL HINT
for Long Houses

Long horizontal homes risk dividing your picture horizontally into three equal parts: background, house and front yard. Stretch the foreground into taking more space. Then look for some way to interrupt the foreground, such as a close-up plant or the shadow of a tree just out of view. Photograph foreground objects or areas as reminders for drawing these extra details.

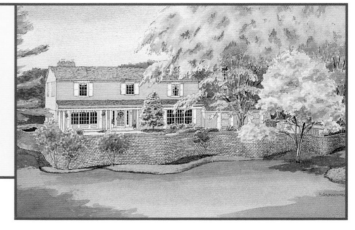

Problem: The sky is uninterrupted by background trees.

You see this most often in new developments. It creates a strong contrast between the sky and a straight roofline, calling attention to an unimportant part of the house portrait.

Solution: Alter your final piece to emphasize other elements.

In a watercolor painting, I try to soften that area by adding some clouds and/or varying the sky color. In a pen-and-ink drawing, I give more space to the foreground, stretching it more than the photo may show. Greater attention to the details of landscaping and high contrast in the house features bring the viewer's attention where it belongs. Design the lines of the grass blades' placement to move the viewer's eye toward the front door.

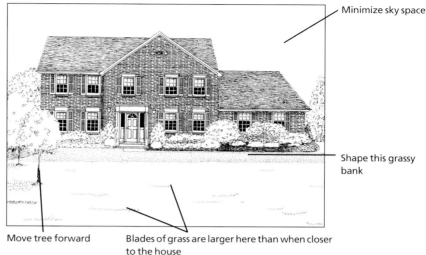

Minimize sky space

Shape this grassy bank

Move tree forward

Blades of grass are larger here than when closer to the house

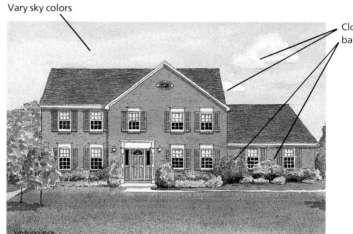

Vary sky colors

Cloud shapes balance tree shapes

HELPFUL HINTS
for Referencing Colors

Do not rely solely on photos for color reference. A photo does not always reproduce color accurately. Strong sunlight, different kinds of film and custom stain or paint colors on the house can lure you into making false assumptions.

Bright sun can make a yellow or pastel-colored house look white in your snapshot. Photograph one shaded side of the house. There will be enough indirect daylight on it to guide you to its real color.

Different brands of film tend to show reds as leaning toward either orange or crimson. One safeguard is to jot down the color you actually see on-site, describing it in terms of the watercolor paint names you use.

Paint a chart of sample brick colors, and keep it in your camera bag. Make the appropriate reference in your notes about this particular house and the sample it best matches. If it does not match, describe it as best you can and later add it to your chart.

Stained wood siding is the playground of creative genius and often defies a simple description. The camera has as much trouble recording its unique color as the artist has describing it in words. For example, did you know that gray can be greenish, yellowish, brownish, bluish or reddish? You had better jot it down and get it right because the homeowner not only knows but probably paid a premium for it. Mix your best remembrance on a scrap of watercolor paper, noting what combination of colors you used. Take it to the site and match it. You might just have hit it right. If not, make notes to correct it.

DRAWING AND INKING

Draw it right the first time. While completing my first house portrait, I discovered I had left no room on my paper for background trees or the prized flowers in the side yard. From then on, with time too precious to waste on starting over, I learned to work from left to right, balancing up and down with careful measuring of all elements in my photos. You really can do this. Trust me.

Start by drawing the outlines of the house first. Work methodically toward the front, where there may be interrupting trees or lamp posts. Then I work from the outward outlines toward the inner details, such as windows, doors and lights.

You must *measure and draw* every detail of the house. You must convert measurements of each part of the house in your photo, made with the engineer's ruler, to proportional inches or centimeters on your steel ruler for drawing on the paper, as described on page 27.

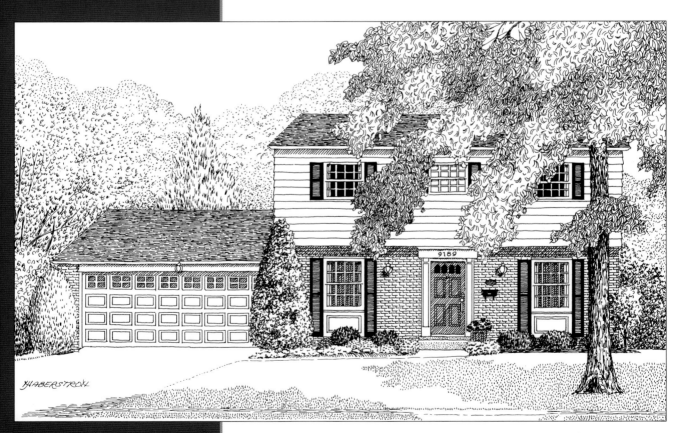

PEN & INK Demonstration One

Steps 1–8 are shown in ink only for purposes of reproduction in this book. However, the drawing procedure is always done in very light pencil.

1 Mark your primary reference photo.

Assuming that the photo belongs to you, use your everyday ballpoint pen to draw a rectangle on the photo, framing the most attractive view. Then choose how big you want the rectangle of your house portrait to be, *proportional* to the rectangle you have drawn on your photo. Choose measurements for your portrait rectangle that easily translate from the engineer's ruler to inches or centimeters on the steel ruler, giving you a workable size. For example, to double the rectangle's dimensions, multiply *each* measurement in your photo by 2. If the photo is not yours, use sticky notes to frame the four sides of the rectangle you plan to use for your composition.

For a house portrait, my smallest size is roughly 6″ × 9″ (15cm × 23cm) for a simple house, such as a one-story home with attached garage and clapboard siding. A medium size of 8″ × 12″ (20cm × 30cm) will accommodate the details of brick siding on a two-story home. A large brick home with two and a half stories, one or more wings and five or more windows across the front might need a 20″ × 16″ (51cm × 41cm) rectangle. Tape the photo to your drawing board for easy and frequent reference.

2 Draw outer rectangle, house foundation and vertical walls.

Select paper at least 4″ (10cm) wider than you plan to draw your rectangle. Leave at least a 2″ (5cm) margin on each of the four sides of your rectangle. Draw your rectangle—in proportion to the rectangle on your photo—in pencil in the center of your paper. On your reference photo, measure the distance from the bottom of the outer rectangle to the foundation. Draw the line that corresponds to the foundation on your paper. Mark from that line the left side of your house and the right side, including from the side of a garage and/or wings.

Using a T-square and triangle, draw all the vertical walls up from that foundation line, working from *left* to *right*. Your drawing is correct when you come close to the right side of your rectangle. Smile, you have done good work. If you run well into the margin, check your measurements and redraw. When these basics are firm, the rest will be easy.

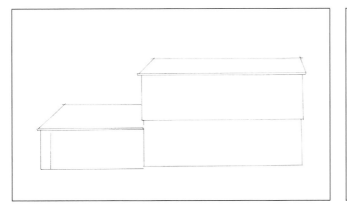

3 Finish outlining the house with roof and gutters.

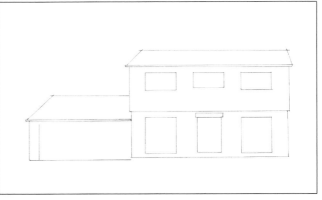

4 Put a face on the house.

Begin details by converting your measurements and drawing the outlines of your windows, shutters and front door.

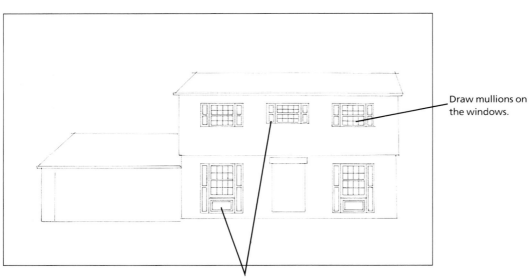

Draw mullions on the windows.

Draw panels on shutters and below the first-floor windows.

5 Add house details.

Divide window space with mullions (decorative dividers on windows). Draw a double line for each horizontal sash division and single lines for mullions. Later, when inking, I draw on each side of the single lines for mullions, making minor corrections for spacing. Draw shutters to indicate their panel pattern, just outlining the space containing the individual louvers.

TIP
for Drawing Siding

Do not draw siding definition, such as brick or clapboard, until after the house outlines are *inked* (see pages 30–32). Landscaping may hide parts of the house, so you save time by drawing only the siding that you really need later.

Dividing Space

Learning to draw siding, window mullions or garage panels evenly and in the correct number can be some of the most frustrating moments of the entire house portrait process. When I first started, my rulers were inadequate, and my high school math failed me. I shall be forever grateful to my numerically nimble spouse, who taught me the method described and illustrated on these pages. He calls it simple geometry; I call it miraculous! You can apply the following basic method for drawing clapboard to windows, doors and other house elements, with a few refinements, later.

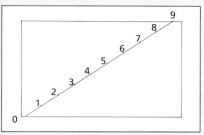

1 Outline the rectangle of the siding area, or area you are dividing, in proportion to your reference photo. Count the siding panels, or elements you are dividing, in your photo. Use a magnifying glass if necessary. Let's say you have nine siding panels to draw. Use the 10 scale on your engineer's ruler (or whatever works for your particular situation—see below). Put the 0 of your engineer's ruler on the bottom horizontal line and angle the ruler towards the top horizontal line until

the 9 rests on it. Draw a light diagonal line with your pencil.

With the ruler resting on the diagonal, mark a dot at each number 1-9 on that diagonal line. The 9 will be on the top of your rectangle.

2 With the head of your T-square firmly positioned against the left edge of your drawing board, draw each horizontal siding line from left to right using the dots as guidelines. Erase the diagonal between the siding lines.

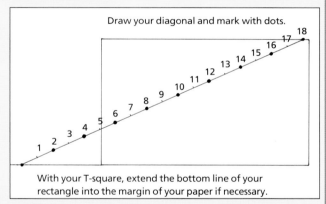

Draw your diagonal and mark with dots.

With your T-square, extend the bottom line of your rectangle into the margin of your paper if necessary.

Problem

Your scale of 0–9 is not long enough to join the top and bottom lines of your rectangle.

Solutions

Try connecting the top and bottom lines using 0–18 on your engineer's ruler (twice the nine sidings required). If that works, mark your diagonal every second number: 2, 4, 6, 8, etc. Then draw your siding with the T-square on those dots.

You can also use your steel ruler and count the ⅛" (0.3cm) markings up to 9 to connect the top and bottom lines.

You can also extend the bottom

line of your rectangle about 2" (5cm). Connect the top with the extended bottom line for a measurement of 9, 18 or even 27. Mark your diagonal accordingly as mentioned (for example, every third number for the 27 to mark nine areas). As you can see, you might need to use a different scale, whether on your engineer's ruler or on another ruler— whatever works for your particular situation.

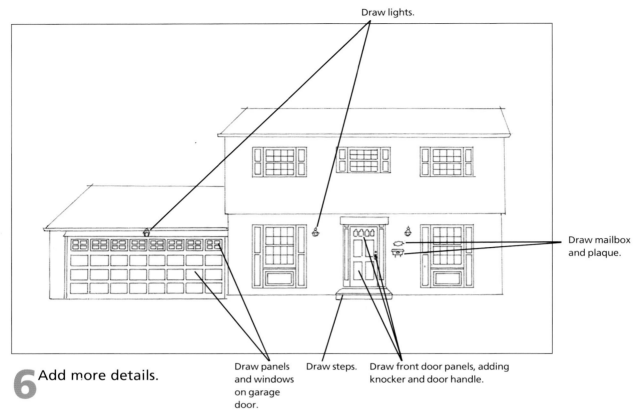

Draw lights.

Draw mailbox
and plaque.

Draw panels
and windows
on garage
door.

Draw steps.

Draw front door panels, adding
knocker and door handle.

6 Add more details.

Count garage door panels across and vertically. Divide space accordingly.

Complete the front door area, adding the panels, door handle, knocker, mailbox, ornamental plaque and lamps. Add the front steps. Divide space for clapboard siding and mark only the edges at this time.

> **TIP**
> *for Detailing Garage Doors*
>
> The garage occupies a large physical part of this picture but does not need extra attention from the viewer. Leaving it without details would invite viewers to focus on a large, open, unimportant space. Filling in that space with windows and panels serves to reduce that focus and connects it architecturally with those panels under the front first-floor windows. Windows usually occupy the same amount of space as a panel, so include them in the space for panels. These design features unify the whole structure.

Mark guides for clapboard siding using proportional division.

Draw the driveway and the sidewalks.

7 Draw the driveway and sidewalk.

Mark guides for clapboard siding (see page 27). Also draw the driveway and sidewalk.

Draw the outline of background and foreground trees.

Draw the outline of all foundation plantings and side yard bushes.

8 Add landscaping.

Draw the outline of background and foreground trees. Pencil the *outlines* of the foundation landscaping and side yard bushes, including any trees that may stand in front of the house. Draw the outline of shade on the lawn and driveway. Erase all house structure lines now obscured by landscaping.

Analyze your drawing for pleasing composition and details. Make necessary corrections.

Inking Procedure

I use the 0.25mm pen and work from front to back, quite the opposite from starting the drawing. Those objects nearest the viewer and obscuring any part of the house, frequently trees, will be inked first. As you move toward the back of the picture, the foreground items hide those behind them, giving a sense of receding space.

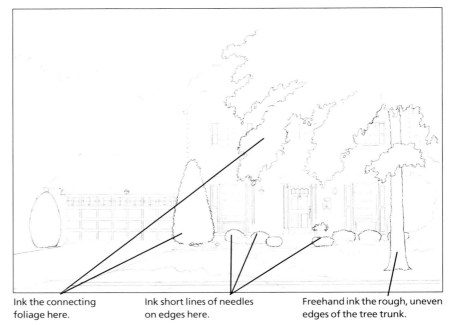

Ink the connecting foliage here.

Ink short lines of needles on edges here.

Freehand ink the rough, uneven edges of the tree trunk.

9 Ink the foliage.

Ink *freehand* the outer edges of foreground landscaping that hide the house, including overhanging tree branches and foliage. Make your pen lines imitate the rough texture of tree bark, evergreen needles and the irregular lines of leaves.

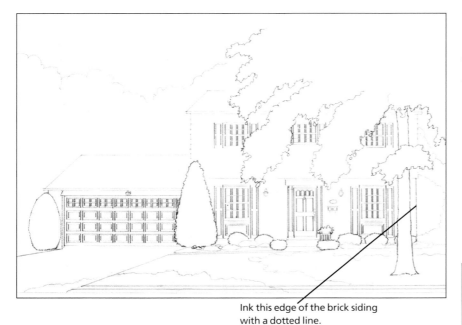

Ink this edge of the brick siding with a dotted line.

10 Ink the vertical lines.

With a triangle and T-square, ink all vertical lines of the house.

> **TIP**
> *for Drawing Brick Walls*
>
> Draw the edge of a vertical brick wall, as shown, with small interrupted lines to show a difference from other kinds of siding.

Use a dotted line here.

These lines and all other horizontals are inked freehand.

11 Ink the horizontal lines.

Ink all the horizontal lines of the gutters, rooftops and steps freehand, but not the clapboard siding at this time.

Ink the diagonal rooflines with small dashes, thereby giving them a softer look. Diagonal lines direct the viewer's eye strongly in a particular direction, and you do not want this kind of emphasis there. Ink the top of the step with narrowly spaced dotted lines, suggesting how the sun hits it. After the ink has dried thoroughly (about fifteen to twenty minutes), erase all pencil lines on the house.

Beginners Only

You have my permission to use a straightedge on long horizontal lines. But please seek to increase your technical skill so that one day you can draw them freehand with confidence. The tiny wiggle of this softer line is a good contrast to the harsh lines formed with a straightedge.

12 Fill in the roof area.

Use various lengths of pen lines, spaced unevenly, to suggest shingles. Then draw your pencil guidelines for the clapboard siding.

TIP
for Drawing Shingles

Pencil some horizontal lines through the length of the roof as guides for keeping the shingles in straight rows.

Use different lengths of pen lines to suggest roof shingles.

13 Ink the clapboard siding and brick.

Now follow your siding guidelines with your pen and ink from edge to edge. Go ahead and try it freehand, particularly when there are interrupting tree branches to shorten each line. You can do this! Draw pencil guidelines for your brick and ink the brick following the guidelines. There are demonstrations of various brick treatments and shortcuts on pages 63–64.

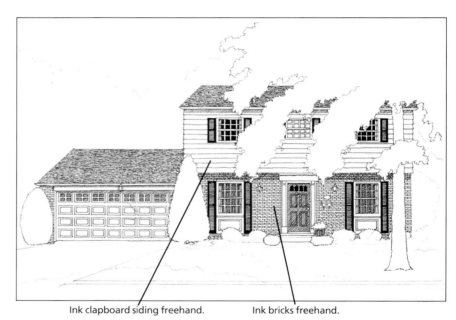

Ink clapboard siding freehand. Ink bricks freehand.

14 Finish house details.

Draw curtains in the windows and fill in the window panes. Add louvers to shutters.

Solid black is the greatest contrast to your white paper and gives a sparkle to the picture. Balance the placement of solid black windows throughout the house portrait, however, so that no one area overpowers another. Study your photo for the level of darkness in each window area that will help focus your picture on the main house area. I chose "gray" diagonal cross-hatching for the garage windows so they would stay subdued in the less important part of the picture. Use the 0.50mm pen for solid black areas.

Finish drawing bricks you might have forgotten at the left of the garage. Yes, I forgot them. Fill in the front door with diagonal lines.

Add louvers.

Make window panes and shutter frames solid black.

Finish inking bricks.

Fill in with diagonals for less contrast.

Draw bricks here.

Ink the front door "color."

Ink diagonals first between mullions and drapes, then ink vertical sheers between mullions.

15 Add shadows to give depth.

To the house, in *pencil*, draw horizontal guidelines to designate shadows, as seen in the photo. In ink, draw diagonal lines within the guidelines. Different ink strokes and their sizes help to characterize the various types of bushes as well as the distance from the viewer.

Ink shadows with diagonal lines under eaves, garage overhang and door frame.

16 Ink all the landscaping, foreground and background.

Finish inking shadows under the coach lamps. Don't forget the shadows on the driveway and grass. Under a bright light, closely examine each segment of the entire house portrait and erase all pencil guidelines, including the original rectangle that frames your picture.

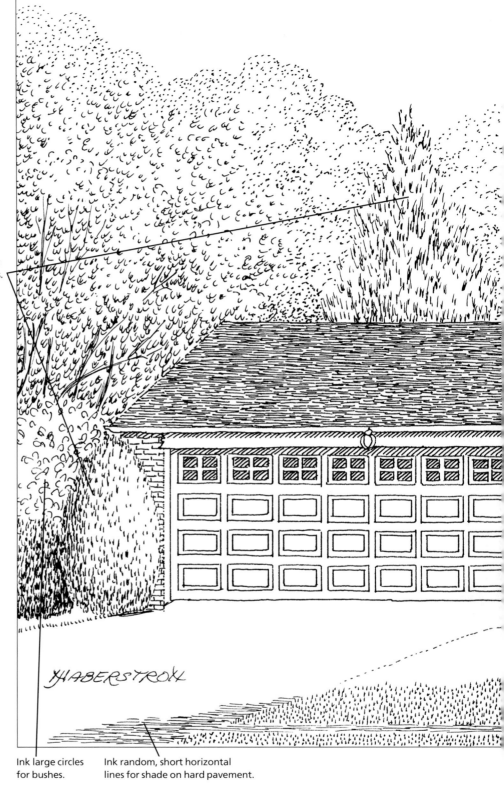

Make short upright lines for evergreens.

XHABERSTROH

Ink large circles for bushes.

Ink random, short horizontal lines for shade on hard pavement.

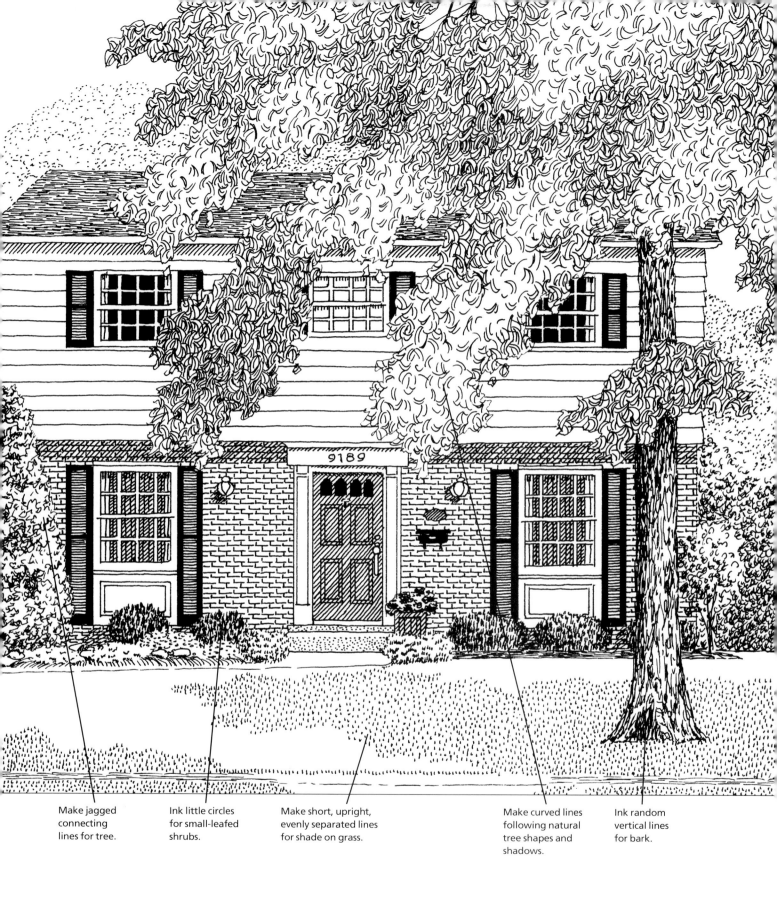

Make jagged connecting lines for tree.

Ink little circles for small-leafed shrubs.

Make short, upright, evenly separated lines for shade on grass.

Make curved lines following natural tree shapes and shadows.

Ink random vertical lines for bark.

9189

PEN & INK Demonstration Two

This house is a nineties style home with its multiple roof peaks and large, decorative windows.

1 Draw and ink the outlines (shell) and inner details (face).

The same rules of drawing in pencil and initial inking apply, no matter how large or complicated the architecture. The shell is complete, as is the face, and I have inked the foreground landscaping.

Because I am right-handed, I move the triangle along the edge of the T-square with my left hand to guide the drawing of verticals. I start at the right side and move left so as not to smear the wet ink just applied. Ink the long horizontal and diagonal lines freehand to form the basic shell and face of the house.

Ink arches, ovals and sills.

Ink the window mullions and interior swags, jabot, valance and mini-blinds.

2 Complete the windows.

Finish masonry details, such as the sills below the windows, the arches above and the ovals venting the attic space. These are easier to see by isolating them with white space before drawing the brick facing.

> **HELPFUL HINT** *for Varying Tasks*
>
> Switching from high-precision work, such as window panes, to a larger area, such as a roof, is refreshing for your eyes and hand. Moving from the creative tasks of landscaping to the tightly controlled shading of the front door and shutters helps you to keep going without burnout.

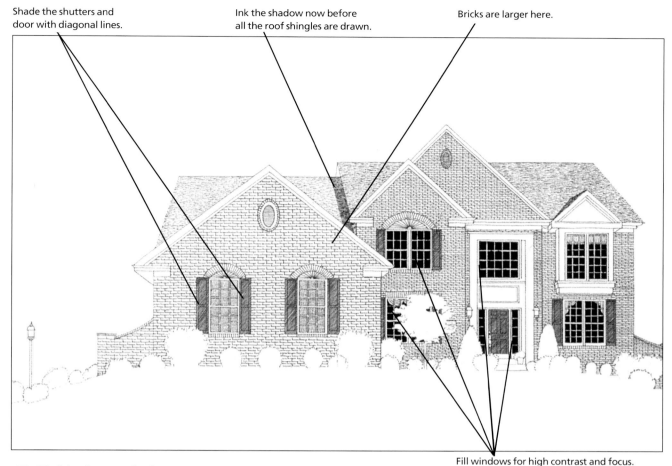

Shade the shutters and door with diagonal lines.

Ink the shadow now before all the roof shingles are drawn.

Bricks are larger here.

Fill windows for high contrast and focus.

3 Finish the roof, shutters and face.

After erasing all my pencil construction lines, I draw the guideline for the roof shadow and ink it first. Then I fill in the other shingles.

In reality, the front door and painted shutters are a gray-blue, in contrast to the brick behind them—they are not black. In order to preserve the panel design and suggest "color," I use closely spaced diagonal lines.

The primary goal of picturing every brick is to give the house a sense of texture and "color," not to promote yourself as a mason. This is, quite honestly, tedious work, but I think the result is worth the painstaking effort. Ink the bricks and blacken the windows, giving the house more character and developing the focus around the front door with its brass footplate.

TIP
for Drawing Straight Lines

Do you find that your hand-drawn horizontal or diagonal lines are dropping down or scooping up at the ends? Try moving one corner of your board up or down or tilting it for a more natural hand and wrist position.

Take a relaxed deep breath before you start your long lines, then exhale slowly and evenly as you draw. This really works. Try it!

Different Brick Sizes

The left wing is closer to the viewer, so bricks appear larger. This is one way to show perspective. Make sure the more distant portions of the house have smaller bricks to push those portions of the house back visually. Larger bricks create a light background to provide contrast to the windows with mini-blinds.

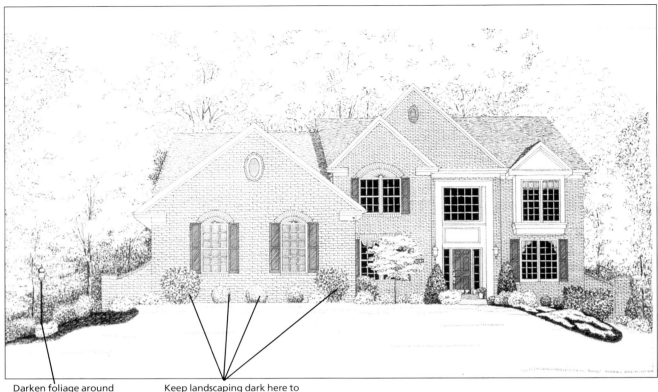

Darken foliage around lamp post.

Keep landscaping dark here to focus attention on the house.

4 Plan foliage placement and effect.

Landscaping places the home in a context its owners know. Analyze the background trees for their placement and effect on the design of the whole drawing.

Carefully plan the open and "white" foliage to balance the large expanse of "white" grass in the foreground. The dark foliage near the house structure contrasts with the brick, thus making the house the prominent art element. Surround the coach lamp with darker foliage so its dark pole does not draw attention away from the front door.

Move Trees for Good Composition

Tree trunks, given a particular view in the camera, have a way of soaring out of a house peak, or even a chimney, and sending the viewer's attention up, up and away. Please move those trees a little to the left or right of the peak's point. If you were to step right or left in front of the house, those trees would move, so you are taking advantage of a natural phenomenon.

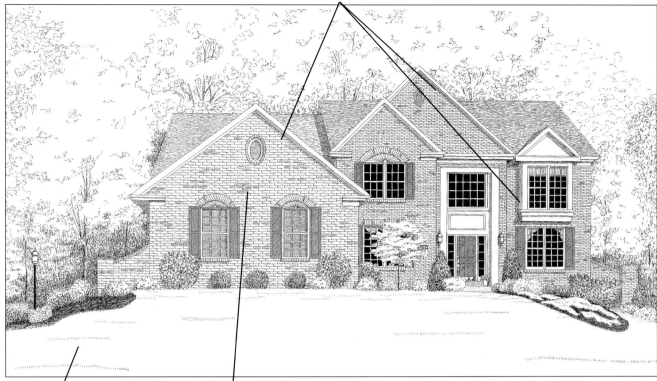

Shadows give a custom look.

Grass blades larger in front than close to the house.

Darker bricks enliven this siding.

5 Define shadows and final details.

Shadows under the overhanging portions of the structure give the picture a three-dimensional quality. Accent bricks give a nice texture to the siding, and my reference photo gives me tips about their placement and frequency.

Grass, as suggested by large blades close to the viewer and increasingly smaller ones nearer the house, conveys a sense of the large expanse of lawn. This modest display of grass also helps to define the bottom border of the picture.

I like to sign my artwork in such a way as not to call attention to the signature. Happily, the grass melds it into the picture.

PEN AND INK WITH WATERCOLOR

I know of no better way to enhance a pen-and-ink drawing than by adding watercolor. You may have heard that watercolor is a difficult medium to use. I am still learning simply by doing, and you can, too—perhaps a little more easily with someone to guide you early in the process. Watercolor is fun to use, wonderfully maneuverable and responds quickly to sudden flashes of imagination. It can be intimidating to paint over all that ink work. A big mistake now could imperil the whole house portrait.

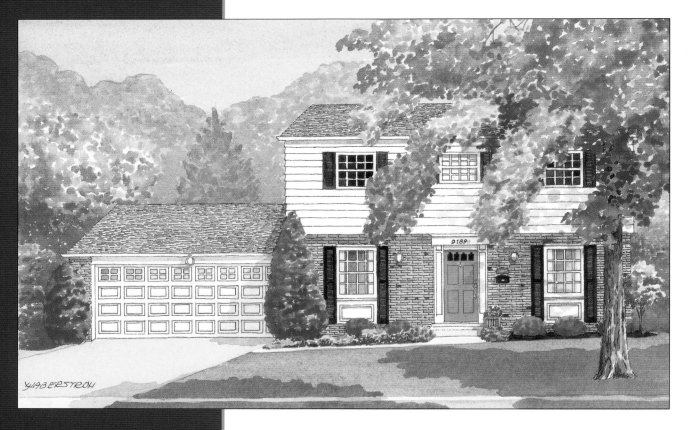

WATERCOLOR Demonstration One

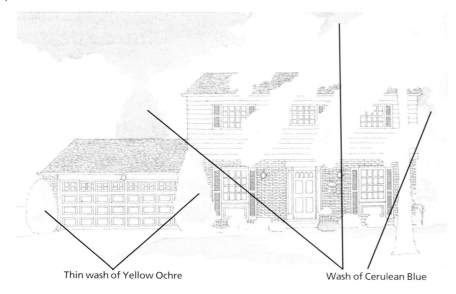

Thin wash of Yellow Ochre Wash of Cerulean Blue

> ### What Is a Wash?
>
> A wash is a small amount of pigment from your tube mixed with a lot of water, which shows a very light shade of the color. I often use washes as underpaintings, building up increasingly darker or different shades of color on top of them as I work. A wash over an existing painted area can also lessen the contrast of one color next to another in order to de-emphasize that part of the picture.

1 Use less ink.

You need less inking for a watercolor portrait. The final inking defines the clapboard, brick and shutters. You will create shadows with your watercolors, so you do not need the ink lines to shape foliage, to show overhanging eaves or to "color" the door and windows.

It is important to let the ink dry at least twenty-four hours before starting the watercolor procedure. Using watercolor prematurely may smear ink and taint the color.

Thoroughly erase all pencil guidelines, including the first rectangle drawn to frame the picture. Watercolor will not cover them, and they can be distracting if not removed.

Tape your picture to your board on all four sides using masking tape that is 2″ (5cm) wide. Paper buckles when wet, but if all edges are secure and evenly taped, it will smooth out as it dries.

Use distilled water in two containers: one for diluting tube paint and the other for rinsing brushes between colors. Keep a pail handy for frequent dumping of muddy rinse water. A medicine dropper is good for removing watercolor from or adding a little bit of water to your palette. Rinse your dropper immediately after you use it for the watercolor so it is clean for the next time.

Keep a paper towel near your mixing palette for blotting your brush when there is too much paint in it or just before rinsing. Keep another paper towel loose and close to your working area for emergency cleanup or blotting.

The dimensions of my painting rectangle, shown here, are 6¼″ × 10″ (16cm × 25cm). Begin by painting the sky. I like Cerulean Blue. Tilt your board so that paint collects in a slim bead along the bottom edge of your horizontal strokes. With a no. 10 sable round brush, begin at the top of the paper and paint in wide horizontal strokes across the page to include that bead, down-

ward to the roof and background trees. Paint this same wash on foliage of a more bluish shade of green.

While the blue is drying, apply a thin wash of Yellow Ochre over the large landscape areas using a no. 10 round sable brush. Paint only on foundation plantings and background trees where there will be no shadows.

> ### Build Your Confidence and Enthusiasm
>
> Picking an easy area to start painting on helps build your confidence before tackling more challenging places. Some general rules are to start with the light areas and gradually add darker tones, as well as to start with the largest areas, followed by the smaller ones. However, it is not important that you do the steps exactly in the order I present them in this book. What counts is your enthusiasm for the process and a willingness to learn from your own practice.

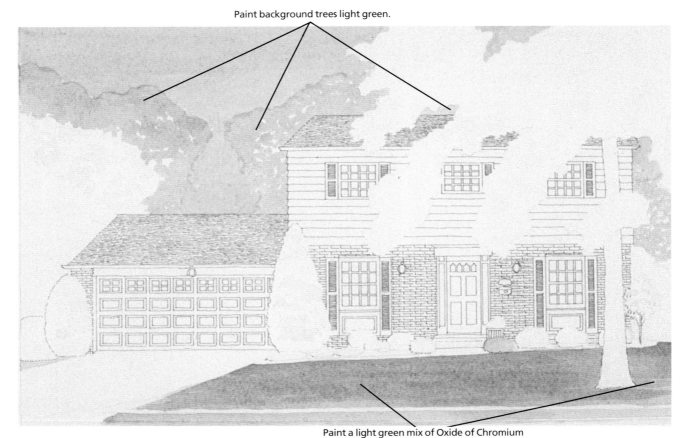

Paint background trees light green.

Paint a light green mix of Oxide of Chromium and Cadmium Yellow. Add a darker green mix of Oxide of Chromium and Ultramarine Blue while the paper is still damp.

2 Paint the grass and background trees.

For the grass, fill a large, flat 1-inch (3cm) wash brush and lay a light green mix of Oxide of Chromium and Cadmium Yellow on the paper in long horizontal strokes. While the paper is still wet, randomly paint the grass area in a darker shade of green made by adding Ultramarine Blue to Oxide of Chromium. Using a no. 7 round sable brush, paint the lighter green on the background trees, defining their edges with its point.

Test Colors on Scrap Paper First

First practice and test your colors on a large scrap of watercolor paper, so you know the color you lay down will be the one you want. This is particularly important with permanently staining colors, such as Oxide of Chromium (green). Think clearly about exactly where you want to apply the paint, then do it boldly. Make notes next to a color mix that was hard to create, just in case you run out of it before you finish the picture.

HELPFUL HINT
for Mixing Colors

Old brushes serve me well for mixing colors with water. This saves wear and tear on good brushes.

3 Paint the roof and brick siding.

Test a diluted Payne's Gray roof color on a scrap of paper to match what the photo shows, then paint a light wash of it on the roof with a no. 7 round sable brush. While the roof is drying, and since a gutter separates the two areas, paint the brick with a thin wash of Venetian Red, using a no. 7 round sable brush.

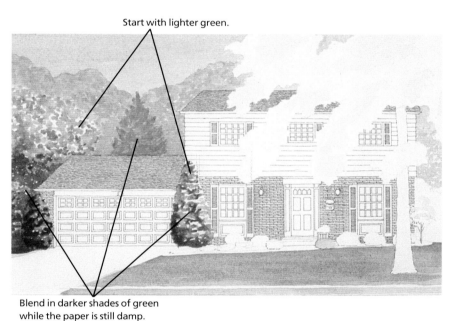

Start with lighter green.

Blend in darker shades of green while the paper is still damp.

4 Shape the bushes and middle ground trees one small area at a time.

Blend colors smoothly while the paper is damp. Add Ultramarine Blue to your Oxide of Chromium to make darker green tree foliage and shape your foundation plantings. Create sparkle by using a no. 7 round sable brush with a good point, painting into the edges of white or "sunshine" spaces as you introduce darker colors.

Give Your Trees Some Sparkle

On successively nearer trees, let the paper show through in small irregular spaces. These will allow you to blend and add different shades of green later, giving your picture a lively sparkle.

Save Areas With Masking Fluid

Are there portions of your picture you do not want to risk covering with an unwanted color, such as accidentally painting the roof or sidewalk with sky blue or tree green? Apply masking fluid to the areas you want to save shortly before painting adjacent areas. When your nearby paint has dried completely, remove dried masking fluid by rubbing with your soft white eraser.

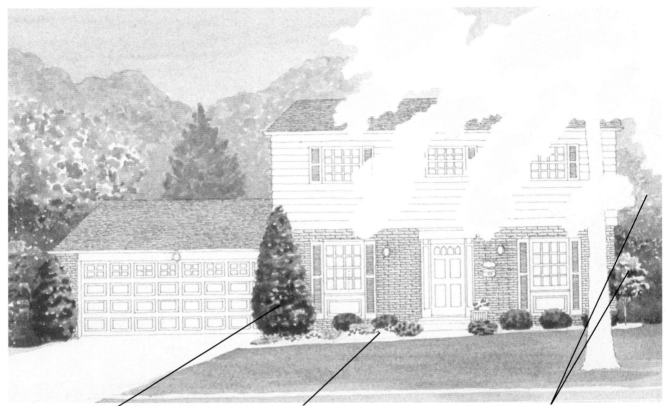

2. Paint foundation bushes with green mixture (Oxide of Chromium and Ultramarine Blue).

1. Paint flower blossoms Cadmium Red Deep.

3. Paint using darker shades of green while paper is damp.

5 Finish most of the landscaping.

Paint the flower blossoms Cadmium Red before painting the bushes, using a no. 0 round sable brush. The white paper showing through the transparency of the paint helps them to show up against their dark green background. Shape the bushes and middle ground trees one small area at a time using a no. 3 sable brush so you can blend colors while the paper is damp.

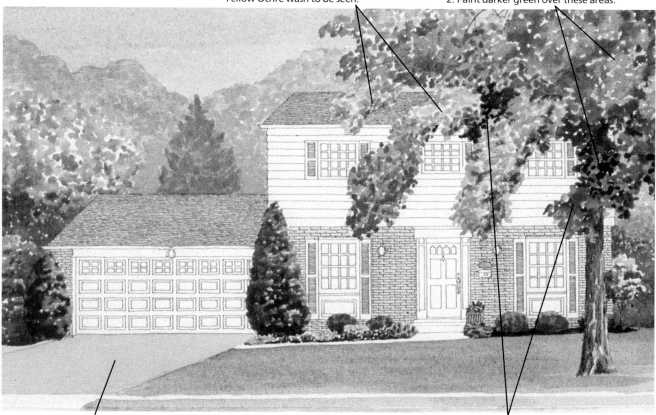

1. Paint light green, leaving spaces for first Yellow Ochre wash to be seen.

2. Paint darker green over these areas.

3. Add very dark greens.

4. Paint driveway with the same wash of Payne's Gray as used on the roof shingles.

6 Paint the foreground tree, driveway and mulching.

Paint the overhanging branches of the large foreground tree with the colors used for the other foliage, using a no. 7 round sable brush. Paint the driveway with Payne's Gray. Paint the tree trunk and mulched planting areas with Burnt Umber using a no. 7 round sable. Start with well-diluted color to lay on a light shade. Add a little more tube color to the first shade to darken successive paint layers.

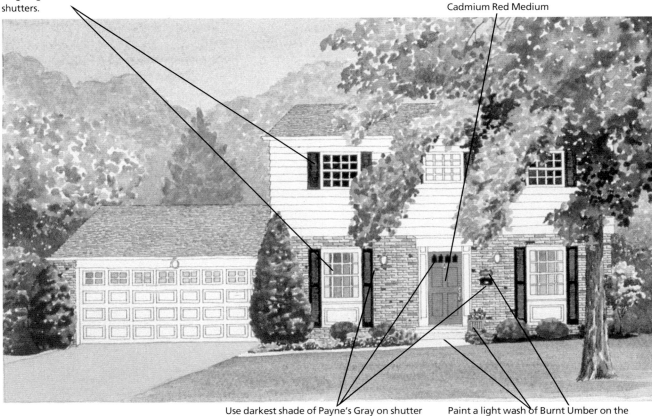

Use Payne's Gray wash, matching the roof color, on garage windows, first-floor curtains and shutters.

Cadmium Red Medium

Use darkest shade of Payne's Gray on shutter frames, mailbox, door windows and accent bricks.

Paint a light wash of Burnt Umber on the planter, plaque, sidewalk and steps.

7 Fill the small spaces.

With medium-dark tints of reds, such as Venetian Red and Cadmium Red Medium, make the bricks look more real by painting a few bricks in a random pattern using an old no. 0 round sable brush that has lost its sharp point. Use shades just a little bit darker than the first wash, as suggested by your reference photo. Use one color at a time, and let the first wash show on most of them.

Paint the whole shutter with a no. 3 round sable brush, using the same roof shade of medium Payne's Gray and letting the inked louvers show. When dry, paint the shutter frame with slightly diluted Payne's Gray from the tube using a no. 0 round sable brush.

Fill in the first-floor and garage windows with medium Payne's Gray, using a no. 0 round sable brush. Paint the second-floor windows, mailbox and accent bricks with the slightly diluted Payne's Gray from the tube. Paint the whole front door with Cadmium Red Medium using a no. 3 round sable brush. When dry, paint the door windows with Payne's Gray using a no. 0 round sable. Lights and door handle get a Yellow Ochre brass color with the same size brush. Sidewalks, steps, planter and plaque have a light brown wash of Burnt Umber using a no. 3 round sable.

> **TIP**
> *for Painting Bricks*
>
> The darkest color should be on the fewest numbers of bricks.

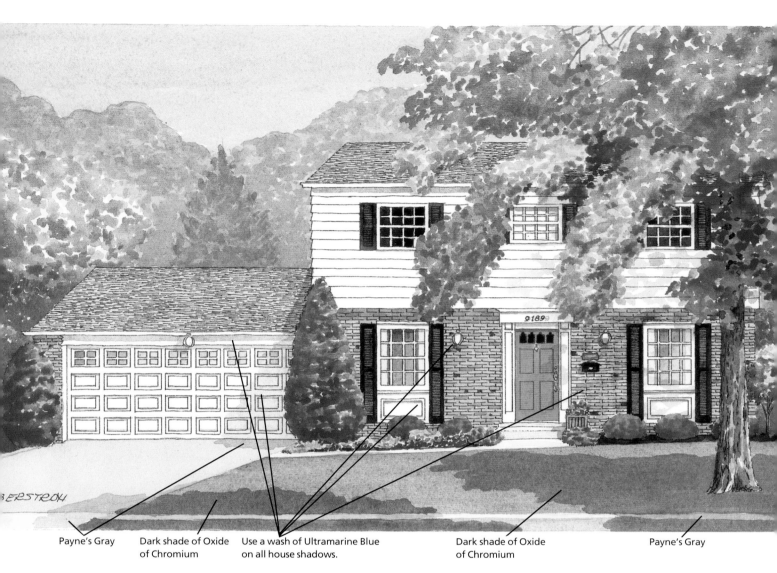

Payne's Gray Dark shade of Oxide Use a wash of Ultramarine Blue Dark shade of Oxide Payne's Gray
of Chromium on all house shadows. of Chromium

8 Paint shadows, and then sign your art.

When the paper is dry, use a no. 7 round sable brush to paint Ultramarine Blue where the sun casts a shadow on the house. Match the dark shade of Oxide of Chromium already in your picture, and paint it on the grass for the cast tree shadows in the yard. On the driveway and side-walk use a light tint of Payne's Gray.

When the paint is completely dry, sign your name with a no. 1 drawing pen or a no. 0 round bristle brush in the lower right or left corner. Pat yourself on the back for a job well done.

WATERCOLOR Demonstration Two

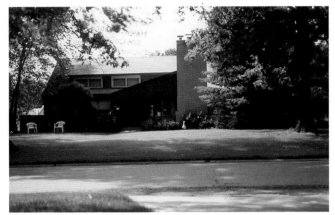

Five Snapshots of the House

Your Aesthetic Center Is Important

The aesthetic center of a picture is slightly above and to the right or left of the actual center. That is the most natural place for the eye to focus and therefore becomes either a powerful tool to enhance a subject or a challenge to the artist. When you locate the front door at the aesthetic center, the house portrait is particularly pleasing. When a chimney is there, you must use diversionary tactics, such as making sure the chimney is in low contrast to its background, while creating high contrast on the front door.

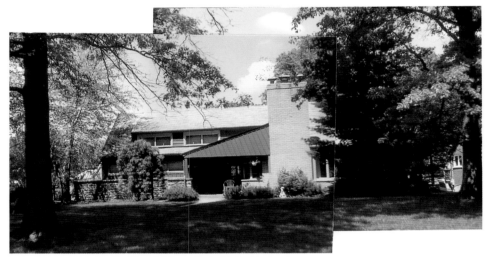

The Whole House in Shadows.
Two photos are aligned and taped together on the back to show the whole scene, because the camera's view could not take the whole house in one frame.

Close-Ups
The front door close-up was essential, since the bright sunlight distorted the very dark shadows of the porch overhang.

Moving an Element
The right side photo of the house shows what the trees obscure. The owner gave me permission to move the pine tree to the right, thereby revealing more of the sunroom as an important feature of their living space.

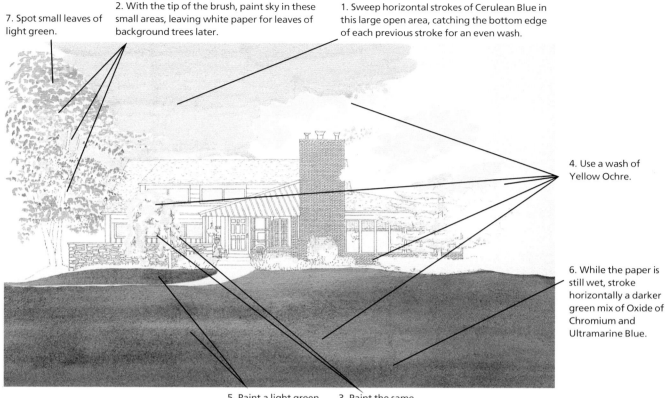

7. Spot small leaves of light green.

2. With the tip of the brush, paint sky in these small areas, leaving white paper for leaves of background trees later.

1. Sweep horizontal strokes of Cerulean Blue in this large open area, catching the bottom edge of each previous stroke for an even wash.

4. Use a wash of Yellow Ochre.

6. While the paper is still wet, stroke horizontally a darker green mix of Oxide of Chromium and Ultramarine Blue.

5. Paint a light green of Oxide of Chromium mixed with Cadmium Yellow.

3. Paint the same Cerulean Blue in shady places.

1 Complete the pen-and-ink drawing and then first washes.

This painting is 8¼″ × 13½″ (30cm × 34cm). It is rendered on Arches 140-lb. (300gsm) cold-pressed watercolor paper from a 16″ × 20″ (41cm × 51cm) block.

Before beginning, refer to page 41 and refresh yourself on the difference between inking for a pen-and-ink drawing and inking for a watercolor painting.

Begin by painting the sky Cerulean Blue and the full sun on landscape areas and the chimney with Yellow Ochre.

Use a no. 10 round sable brush with a good point to control the flow of paint next to the roof and around the background trees.

The chimney presents several challenges. Its large size and placement near the aesthetic center (see page 48) of the picture are potential

problems, as is its color. Brick color, depending on which photo I study, is either tan or yellow. Using several soft colors revealed by the reference photo under a magnifying glass will help reduce focus on the chimney. Paint a Yellow Ochre wash over all the bricks.

Keeping grass softly modulated with various colors of green contrasts nicely with the highly defined, rigid pen-and-ink lines. Load your large flat 1-inch (3cm) wash brush with Oxide of Chromium (green) mixed with Cadmium Yellow to produce a sunshine green. Lay in the paint below the sidewalk line all the way left and right across, and work down the paper to the bottom edge. Do not rinse the brush. Blot it on a paper towel to remove some of the first color. Then pick up the next

Problem: When you paint a large area of dry paper, it is difficult to lay down a smooth wash, because hard edges appear between strokes.

Solution: Dampen the paper.

I dip a paper towel into clean distilled water, press out most of the excess and firmly stroke the paper, but only in the large expanse I want to paint. For example, in Step 1 keep away from the line of the sidewalk. The large size of this area will require several applications, working quickly to ready the paper for immediate painting.

darker green from the palette and stroke it randomly into the first paint layer, both in the sunshine and where the cast shadows will be later.

Turn the board upside down and use the no. 10 round sable brush to paint that small, dry strip of grass above the sidewalk. Start with the area near the front step and move the paint across in about 1″ (3cm) segments, carefully delineating the long edge of the sidewalk. This procedure keeps the paint from drying out at the end of the stroke. A large brush will hold enough paint for that whole area without risking premature drying time because of a return trip to the palette.

Holding the same brush upright, lay little bits of lightest green (Oxide of Chromium/Cadmium Yellow mixture) in the foliage area, letting white, yellow and blue sky spaces show.

2 Add a second layer.

Add a second layer of slightly darker green to new spaces as well as on top of the first layer of green. See how you can create a third shade of green with only two applications.

Add darker green leaves over light green and into some of the white, letting some of the light green and white background show.

3 Paint the right foreground foliage.

With the no. 10 brush, paint the lightest green in large areas on these branches, thus conveying closer proximity to the viewer. While the paper is damp, introduce your darker greens (a mixture of Oxide of Chromium/Ultramarine Blue) to shape the branch's foliage as suggested by your photo. Overlap previous layers and move into newer areas, making each a different size but consistent in shape.

Lay in a mass of light green, letting some Yellow Ochre peek through; then add your darkest green to shape the foliage.

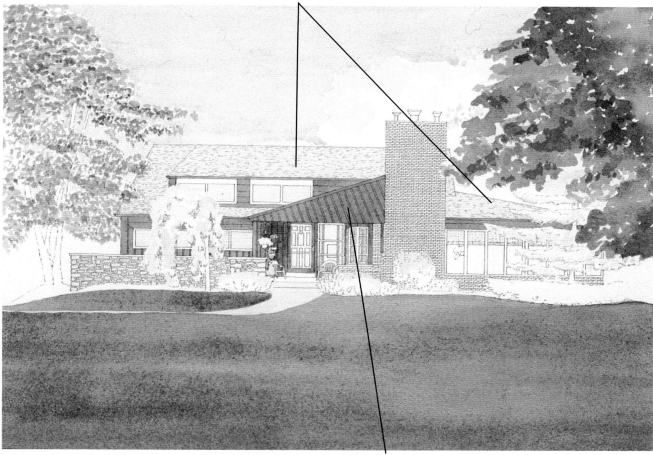

Use a light wash of Burnt Umber.

Paint a medium dark shade of Burnt Umber.

4 Return to the house.

Though my photo seems to have a blue tint common to the type of film used, I think a brown roof is a better artistic choice, harmonizing with the brown siding. Use a very light wash of Burnt Umber on the roof and, while that color is handy, on the stone wall, sidewalk and front step. Using a darker shade of Burnt Umber, give the wood siding its first coat of paint.

TIP
for Mixing Greens

Mix at least four different greens in separate palette pans before starting your landscaping. The lightest is a mix of Oxide of Chromium and Cadmium Yellow. Successively darker shades start with Oxide of Chromium and add increasing amounts of Ultramarine Blue. You can lower the intensity of a green by adding just a wee bit of Cadmium Red Medium or Venetian Red.

TIP
for Small Spaces

When painting areas such as the roof and siding, keep a small brush loaded with the color you are using. That way, you can get into small spaces that are difficult to paint with the bigger brush. You need to paint all spaces as you come to them so the paint flows and dries evenly.

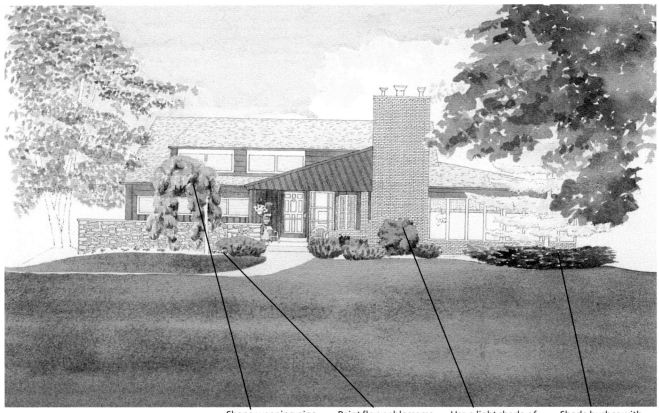

Shape weeping pine with darker green while paper is wet.

Paint flower blossoms with Cadmium Red.

Use a light shade of green.

Shade bushes with darker greens while paper is wet.

5 Paint flowers and foundation plantings.

The Cadmium Red petunia blossoms are first, leaving blank paper for the white ones. While the paint is in your brush, you can plant flowers in the hanging basket.

The first layer of light green on the bushes allows you to blend in darker shades while the paper is still damp. When the paint is dry, I add even darker green (more Ultramarine Blue and less Oxide of Chromium) to define their foliage patterns.

TIP
for Painting Foliage

Seeing the patterns and shapes of dark areas in the reference photo can help you paint shaded foliage realistically. Darks, simply by their contrast, also define the shapes of the leaves in the sunlight.

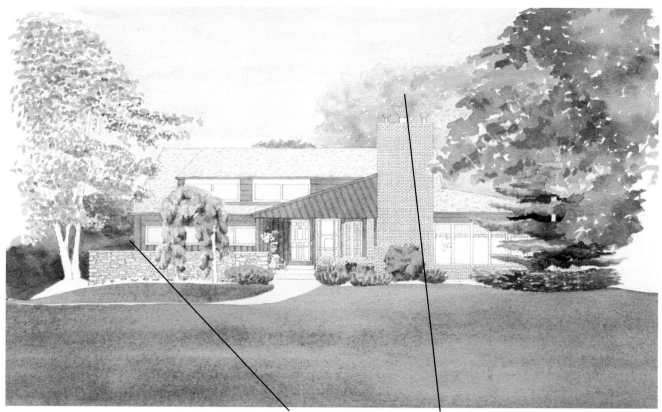

Paint your third darkest green. Paint light tones of green.

6 Finish the background.

My photo shows a neighbor's house behind the birch tree on the left. Artistic license allows me to replace the house with background trees and give the picture better balance.

The background foliage above the roof is next. Dip your clean brush in clear distilled water and then into a little light green paint and apply to the sky edges of the foliage. Add slightly darker colors while the paper is wet, but not so dark as to create a strong contrast with the chimney.

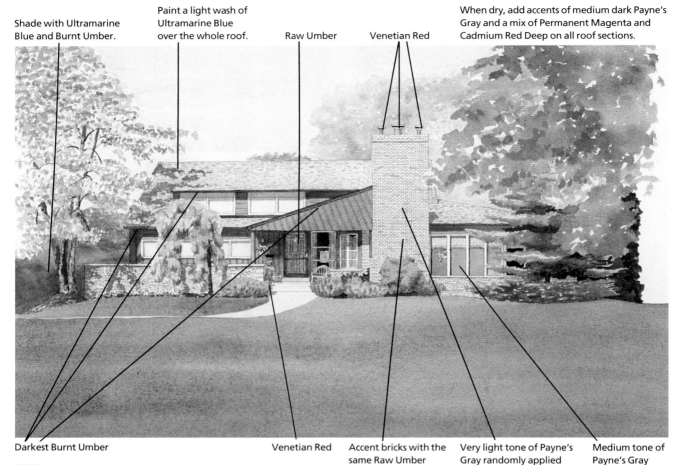

Shade with Ultramarine Blue and Burnt Umber.

Paint a light wash of Ultramarine Blue over the whole roof.

Raw Umber

Venetian Red

When dry, add accents of medium dark Payne's Gray and a mix of Permanent Magenta and Cadmium Red Deep on all roof sections.

Darkest Burnt Umber

Venetian Red

Accent bricks with the same Raw Umber

Very light tone of Payne's Gray randomly applied

Medium tone of Payne's Gray

7 Finish the house and landscape.

A check of the house confirms the roof is a mottling of blue and accent red, so I must correct the Burnt Umber I laid down earlier for this commissioned work. Two options are possible: erase the brown with a strong abrasive or electric erasers, or paint over it.

Erase only as a last resort, because that irrevocably damages the paper, preventing smooth color application. Painting over is much better, and the right color is a wash of Ultramarine Blue. When it is dry, paint small areas of medium dark Payne's Gray and a mix of Permanent Magenta and Cadmium Red Deep on top, giving a decorative and realistic effect.

While the roof is drying, give the front door, inside shutters and accent bricks a coat of Raw Umber. Use a lighter wash of the same color on the roll-up window shades of the right wing.

Payne's Gray is my favorite for window spaces. The darkest shade goes on the front porch window, a strong focus area, and on the shaded windows behind the dark fir tree. A medium intensity keeps the contrast minimal on those windows near the chimney.

Looking closely, my photo shows a random massing of very light Payne's Gray on the chimney bricks. Perfect! I need a third color here. You can use Venetian Red on the

chimney flues and to define the clay pot on the front porch. Medium Payne's Gray shapes the stones of the stone wall.

Apply a medium wash of Burnt Umber on the tree trunks, followed by Ultramarine Blue, particularly in the portions shaded by branches and away from the sun. Finish the landscape by adding leaves to the petunias and other flowers, then add mulch to the foundation plantings, and fill in the backyard foliage seen through the porch window.

Add accents, final touches and cast shadows. Accent the architecture with Burnt Umber in its darkest concentration. These details add sparkle to the house portrait.

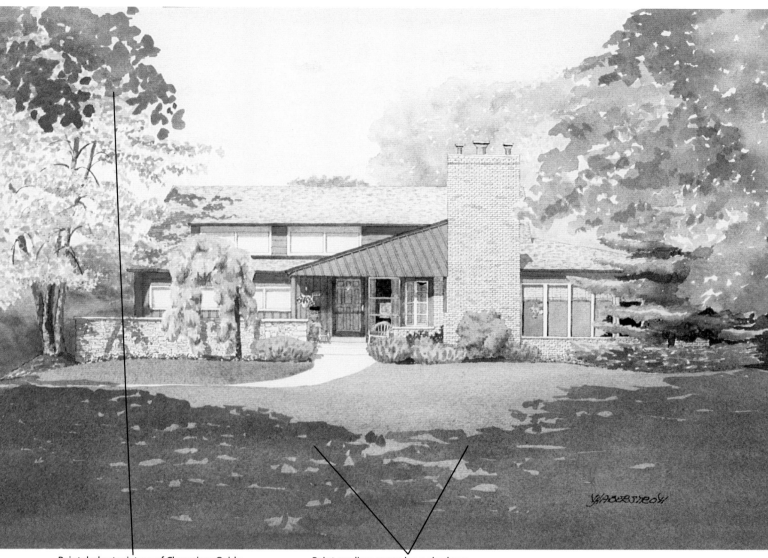

Paint darkest mixture of Chromium Oxide and Ultramarine Blue.

Paint medium green lawn shadows.

Cast shadows are an opportunity to introduce a bright new color, particularly when the rest of the painting is quiet to the point of being dull. Ultramarine Blue is my choice for creating a lively house portrait.

8 Put in the final touches.

Branches of leaves above the spectator's head and cast shadows in the yard put decorative accents on the painting as well as convey the lush abundance of trees in the yard. Sign your name.

One Bush at a Time

Do not paint one color of green across all of the bushes just because your brush happens to have enough color for all of them. *Do* work one bush at a time while the paper is damp for easy blending of shaded areas. Use a no. 5 round sable brush with a good point, and *do not* rinse it between color applications. Just blot excess paint on a paper towel and pick up the next darker color.

TIP
for Creating Distance

Foliage colors in the background have minimal contrast with the sky and have softer shades of green defining their inner shapes. The little sparkles of space are much smaller than on the foreground trees.

BREAKING IT DOWN: ELEMENTS AND TEXTURES

Houses reflect their owners in curious and interesting ways. The variety of elements seems endless, as are their often imaginative, bold, subtle or repetitive combinations. The following demonstrations will help you understand what you see, then enable you to put your hand and tools to work.

Linear perspective can get very technical and intimidating. Many good books exist on linear perspective, if you want to study it in more detail. If you find that you feel more at ease having your angles more exact, use the basics that follow. If you feel more at ease with going with what looks right, but is not exact, see "Drawing the Basic House Using a Sight-Judgment Method." Use whichever method fits you best.

THE TECHNICAL SIDE OF LINEAR PERSPECTIVE

Some basics to remember are:

• *Horizon line*: Also called *eye level*, this is the horizontal line of sight into which objects seem to vanish. To see how it works, go outside, stand up and look straight ahead. Objects seem to vanish into or sit on this imaginary line. Sit down, and you see those same objects differently.

• *Vanishing point*: Ordinarily, there are one or two vanishing points. Imagine standing in the middle of a road. The road seems to vanish into one point on the horizon line. In two-point perspective (two vanishing points), two lines of sight seem to vanish in opposite direc-

tions on the horizon line. In this book, you will be working with two vanishing points. Label these two points VP[1] and VP[2] (for vanishing point 1 and vanishing point 2), if you wish to use the more technical method.

• *Groundline* or *baseline*: This is a horizontal line from which you will base the *beginning* of your drawing.

As you can see, the illustration on two-point perspective shows a groundline from which to begin a drawing. Using a box, with the closest point to you resting on the groundline, two lines are drawn to the horizon line, or eye level. Notice

that they come to two points (vanishing points). Two vertical lines are drawn on the left and right within these triangles to show where the box ends on either side. The left and right vanishing points are labeled to keep them separate in your mind while drawing. They are reference points for lines you may draw later.

Many times, vanishing points extend off of your page. If you wish, you can tape cardboard with drafting tape to your paper and continue your horizon line on out to find your vanishing points.

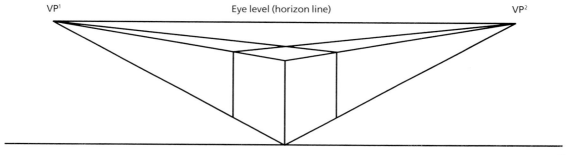

VP[1] Eye level (horizon line) VP[2]

Groundline

Two-Point Perspective
If the corner edge of a cube is closest to you, then you can see both flat planes. They can each have a vanishing point far beyond both sides of your vision.

DRAWING THE BASIC HOUSE USING A SIGHT-JUDGMENT METHOD

The sight-judgment method is the method we will be using in this book. A house portrait showing two sides as seen from an angle is much more interesting than the straight-on view. You expose more living space by showing the second side, making your house portrait particularly meaningful to its owner. Follow this demonstration of linear perspective and you will see that it forms the basis of every kind of house you may depict, as well as particular elements of a house, such as siding. Use your pencil, triangle and T-square.

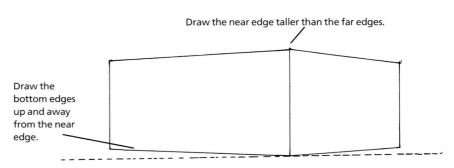

Draw the near edge taller than the far edges.

Draw the bottom edges up and away from the near edge.

1 Think of a box seen from an angle.

Think of a house as a box turned with one corner closest to you.

The first and largest box you draw will set the stage for all its other parts. Draw a groundline and the edge of the near corner, as shown. You can see two sides of the house, with each side having a suggested vanishing point far beyond both sides of your vision. This means that the edges of the far corners appear shorter than the near edge, and the top and bottom edges of the box appear to converge as they move farther away from you. For example, the bottom edges slant up and away from the groundline and near edge. Each line will be the guide for the next one, so you need to observe carefully and draw these first ones as correctly as you can. Each wing of a house is merely another box.

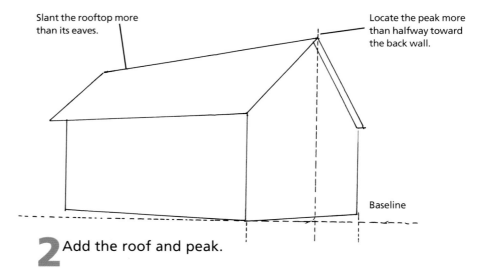

Slant the rooftop more than its eaves.

Locate the peak more than halfway toward the back wall.

Baseline

2 Add the roof and peak.

Locate the peak more than halfway toward the back wall, as shown here. The top ridge of the roof slants down at a greater angle than the bottom edge of the roof (again, both these lines slant toward the same suggested vanishing point on the left).

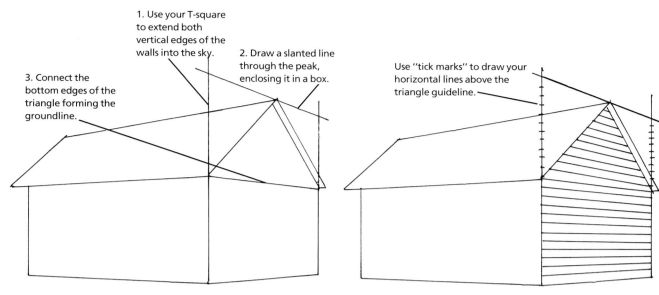

1. Use your T-square to extend both vertical edges of the walls into the sky.

2. Draw a slanted line through the peak, enclosing it in a box.

3. Connect the bottom edges of the triangle forming the groundline.

Use "tick marks" to draw your horizontal lines above the triangle guideline.

3 Draw the siding divisions.

Again, spaces are narrower at the far edges than at the near edge.

> **HELPFUL HINT**
> *for How Much of a Slant to Close in the Top of the Box*
>
> Mark your *photo* with a ballpoint pen in these steps:
>
> **1** Place your straightedge on each wall in turn, and extend the wall lines from the triangle base of your peak into the sky. Press hard on the pen to make a visible line, even scoring the photo if necessary.
>
> **2** Draw the diagonal line shown by the siding level two boards down from the peak and connect the wall extensions. This is the angle of the line you need to form the top of your box.
>
> **3** Use easily removable drafting tape to attach your photo close to your drawing, with the vertical lines perfectly matching both photo and drawing. Check placement with your T-square and triangle. Set a straightedge lightly on the photo's diagonal line and move it evenly onto your drawing. Draw that angled line for the top of your box.

4 Draw siding on the peak.

See a triangle when you look at the peak of a house or a dormer, but *think* "box" in order to continue the siding realistically from the ground level into the peak. In *pencil*, make a box from peak to ground. Extend the wall lines of your triangle into the sky. Lightly draw the base of your triangle where the angled peak sides meet the two walls. Close in the top of the box with a diagonal line more slanted than the base guideline of the triangle.

Measure and mark siding spaces. Do this on the extended walls of your peak all the way to the ground, one wall at a time as described in chapter three (page 27). Connect the wall guidelines with your straightedge, and draw only within the triangle of your peak. Erase all guidelines with your kneaded eraser.

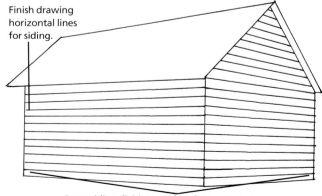

Finish drawing horizontal lines for siding.

Draw siding divisions so that the spaces are narrower at the far edges than near edges.

SHINGLES AND SIDING STEP BY STEP

Shingled siding conveys a decorative touch to the house portrait. It needs clear definition so as not to be confused with clapboard siding. Its use also defines a particular era in house construction, which is important when you are recording a historical structure. Drawing a grid guideline provides a firm base for this detailed work.

The basic procedure using a grid with odd and even numbered rows, as shown here, will apply to other siding as well. It should help you quickly and accurately produce a reasonable facsimile of shingled siding. For simplicity, this demonstration is of the straight-on view.

Grid

Grid of horizontal and vertical guidelines

1 Draw a grid.

Draw your grid of horizontal and vertical guidelines in *pencil*. (Grid shown in ink only for clarity of reproduction.)

> **Problem:** The natural rhythm of breathing and hand motion can work against you in repetitive activity. You can easily draw random lengths in one line and then unwittingly duplicate that pattern on the next lines. Varying the shingle widths is also fraught with pitfalls unless one is wary.
>
> **Solution:** Consciously subduing your natural impulses will yield satisfying results when you depict the random-width siding. Its decorative pattern will add a pleasing authenticity to your house portrait. Slow your breathing while drawing or inking.

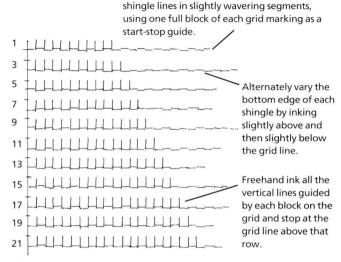

Freehand ink all the individual horizontal shingle lines in slightly wavering segments, using one full block of each grid marking as a start-stop guide.

Alternately vary the bottom edge of each shingle by inking slightly above and then slightly below the grid line.

Freehand ink all the vertical lines guided by each block on the grid and stop at the grid line above that row.

2 Number and ink the odd rows.

Shingles can become very confusing if you try to do them one line after the next. The simplified process described here will enhance your enthusiasm for this kind of detail, which can be tedious. Number the odd rows in *pencil* (that is, 1, 3, 5, 7, etc.). Ink these rows as shown by following the pattern of the grid lines both horizontally and vertically.

3 Ink the even rows.

Erase odd numbers, pencil in even-numbered rows and ink as shown.

These rows require more concentration because you will be working *between* grid lines, first horizontally with the shingle bottoms then vertically to mark their width.

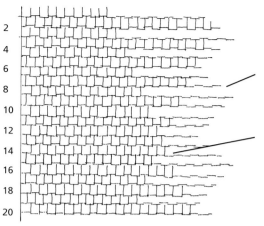

Freehand ink all the individual horizontal shingle lines in the same jiggly segments starting and stopping at the halfway point between each block of the grid. Vary the bottom edge of each shingle just as you did on the odd-numbered rows.

Freehand ink all the vertical lines. Notice that each hits the middle of the shingle in the row above.

Wrong Way

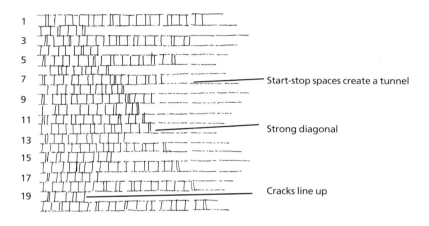

Start-stop spaces create a tunnel

Strong diagonal

Cracks line up

Right Way

Vary the tiny spaces between the horizontal segments from line to line.

Place similar shingle widths in a truly random pattern, up and down as well as side to side.

Place each shingle of every width so that it spans the crack between the two in the row above it.

What About Random-Width Shingles?

Draw guidelines in *pencil* for the horizontal lines only, and be aware of easy-to-make and subtle errors. Remember: Random is not simple rote repetition. You really have to pay attention to your work during this inking process.

ANGLED-VIEW SHINGLED SIDING STEP BY STEP

Use linear perspective to make brick and shingle siding more realistic. Think of telephone poles along a street, which disappear into the horizon. Using a vanishing point, the poles become shorter as they approach the horizon. The poles are also spaced closer together as they near the horizon. In the same way, draw bricks or shingles on a siding angled away from the viewer vertically shorter and more horizontally narrow as they reach the end of the wall farthest from the viewer. Use this for drawing your shingles.

1 Draw a grid.

Draw your grid of horizontal and vertical guidelines in *pencil*. Horizontal guidelines are the same as for clapboard siding—their height is shortened as they move away from the viewer toward the vanishing points. Vertical guidelines gradually diminish from near to far wall edges, whether for evenly or randomly spaced shingles. On a small picture, 6″×9″ (15cm×23cm), divide the siding into thirds in order to reduce the width of the shingles in an orderly way, as shown. On larger pictures, decrease the width measurements of each shingle in groups of one fourth, moving from the nearest to the farthest wall edges. Although this isn't as gradual as it really appears, the sense of distance is achieved without the struggle of highly mathematical formulas.

On the less important, smaller and usually shaded side of the house, you do not need to show the vertical shingle divisions. The horizontal segments will suggest the continuation of that type of siding.

Draw Grid in Pencil
Divide wall edges and draw horizontal guidelines as you would for clapboard siding, as described in chapter three.

3. Make this third group narrower than the middle group.

2. Draw these shingles narrower than in the first group.

1. Draw first group of shingles.

Ink the Shingle Siding

Draw long, slightly wiggling lines to indicate a rough edge to the bottom of the shingles.

On the odd-numbered rows, draw vertical shingles on the grid.

On the even-numbered rows, draw the verticals spanning the rows above.

No verticals are needed in this shaded side.

2 Ink shingle lines.

Freehand ink the horizontal and vertical shingle lines.

Use the same guidelines on the grid for odd- and even-numbered rows as described for the straight-on view, except on the shady side as noted, making sure that the cracks meet a solid shingle in each row.

BRICK SIDING STEP BY STEP

Brick gives texture to a house, conveying the artistry of the mason. You should render its texture and color faithfully whether by pen alone or with watercolor. Ink lines are critical when you don't add watercolor. Draw all inked lines freehand. The almost imperceptible quiver in the line subtly conveys brick's rough edges.

1 Draw guidelines.

Pencil guidelines for brick as you do for siding.

As with siding, these guidelines will usually not faithfully represent every row on the house. Draw them small enough to be realistic, keeping perspective in mind as described for the angled siding wall at the beginning of this chapter (see page 59) as necessary. What is the distance between horizontal lines? On a large two-story house portrait (at least 8″ × 12″ [20cm × 30cm]) mark one edge of the wall every 1/16″ (0.2cm), top to bottom. On smaller portraits, use the centimeter scale and mark each centimeter. If you are drawing the wall straight on, use your T-square to draw lines across, skipping over window spaces you've already drawn, as described in chapter two.

On an angled wall, make the same number of marks on each wall and connect those marks with a straight-edge, as for clapboard siding. How wide is a brick? Three times the height of the siding lines, so mark bricks at that width all across the siding (be sure to make them smaller as you go back on an angled wall, just as the height of the siding is less). For example, if the brick is 1/16″ (0.2cm) high, it will be 3/16″ (0.5cm) wide. Use your triangle and T-square to draw vertical guidelines at each mark. Most bricks are not aligned in a strict grid as shown, so most often you won't be drawing them all directly over the guidelines. However, this grid is helpful for positioning your bricks in whatever pattern they are laid.

2 "Color" the brick.

"Color" your brick using ink lines.

Ink lines must produce the right "color" for your bricks when you do not have the luxury or ease of pigment from watercolor. Here are a few ways to start, though you will probably discover some techniques of your own as you become adept in

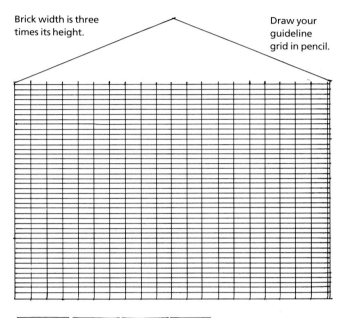

Brick width is three times its height.

Draw your guideline grid in pencil.

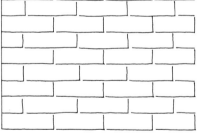

Use this pattern for brick in a watercolor house portrait and where bricks need to be a light color.

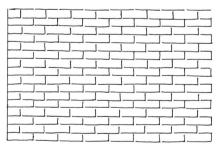

Draw smaller bricks to convey a sense of slightly darker but consistent color.

this medium.

For the lightest "color," ink only the bottom and one edge of each brick to indicate texture on a finished pen-and-ink house portrait and as an excellent background for watercolor. The least number of lines identifying brick, the lighter the color will be.

For medium "color," ink two horizontal lines within each penciled brick outline and do not add ends. Ink one row at a time, alternating their placement. This color provides a good contrast for light-colored shutters.

For dark "color," outline each brick, leaving horizontal and vertical mortar space between each. Fill in each brick with short vertical lines. While this method is the most tedious, it suggests very old, dark brown brick in some historic buildings.

Leave small spaces between the bricks evenly up and down the odd-numbered rows.

Angle of the sun

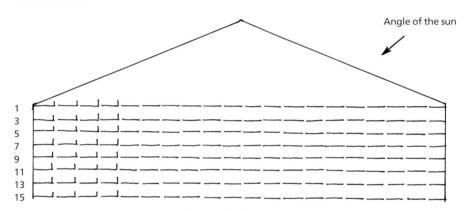

Turn drawing one-quarter turn and add ends to bricks.

Draw broken lines for bricks in even-numbered rows and add ends.

Draw two horizontal lines inside each brick on your grid for a medium color.

Darkest color

Outline each brick, leaving mortar space around it.

Fill in each brick with vertical lines.

Bricks in the Shade

Draw a pencil guideline to enclose the shaded area. Ink closely spaced diagonal lines within the guideline. Space diagonal lines farther apart on light-colored wood framing within the same area.

For the shaded side of a house, ink rows of bricks with small dots along only their horizontal lines. Add diagonal shade lines evenly and closely spaced to the whole wall.

Painted Bricks

In the sun, ink short dotted lines on the lower edges of some bricks in small groupings and in a random pattern throughout the wall. In the shade, ink dotted horizontal lines throughout the shaded area, and ink solid lines for the ends of the bricks. Ink shaded woodwork with diagonal lines.

HELPFUL HINT
for Shaded Wood and Brick

Ink wider lines across the whole area of wood and brick, then fill in between them for the shaded brick.

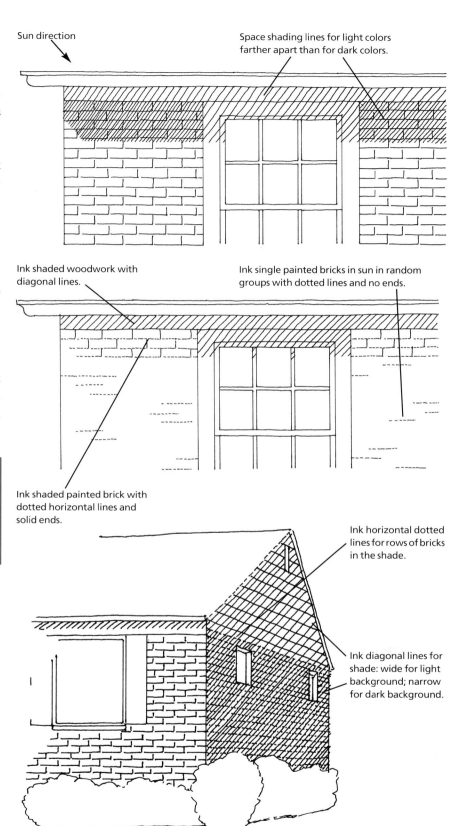

Sun direction

Space shading lines for light colors farther apart than for dark colors.

Ink shaded woodwork with diagonal lines.

Ink single painted bricks in sun in random groups with dotted lines and no ends.

Ink shaded painted brick with dotted horizontal lines and solid ends.

Ink horizontal dotted lines for rows of bricks in the shade.

Ink diagonal lines for shade: wide for light background; narrow for dark background.

DECORATIVE BRICK DETAILS

These designs can occur in many places, such as over windows and doors. They add a distinct flair to the home. Enhance the authenticity of your rendering by observing and drawing these details. Your close-up photo is a critical resource.

Simple Brick Decoration

Draw one horizontal guideline the length of one brick above and spanning the window or door. Ink the vertical bricks freehand. The bricks on the ends are often triangular.

Simple Brick Decoration

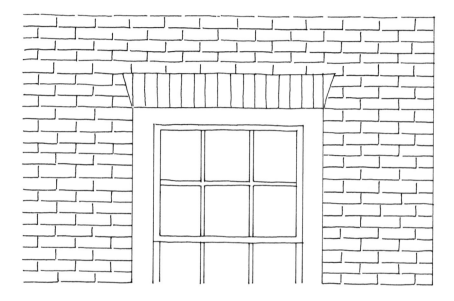

ARCHED BRICK STEP BY STEP

1 Draw the bottom of the arch.

Draw the bottom of the arch and connect sides to a top guideline dot.

Measure to the highest point of the arch. Make a *pencil* dot there. Then draw the top arch in the same way. Draw a broken curved line connecting the corners of the window or doorway through the center of the arch. Note from your photo whether there is a keystone in the center, and put it in if there is.

2 Draw the arch bricks.

Draw bricks tilting away from the center brick or keystone.

Draw with *pencil* an arch between the top and bottom arch lines to help you measure and mark the proper brick width along this line. While I trust the mason to add extra mortar between the bricks on the top arch, I do not try to depict this much realism. Each brick will therefore be a little wider at the top and narrower at the bottom. Draw your bricks in a gradual tilt right and left of the center brick or keystone. The last brick may be a triangle. Historical buildings may have multiple layers of bricks in arches that span either windows or doorways with vertical windows on either side.

HELPFUL HINT *for Drawing Arches*

A plastic template of various sizes of circles is a valuable tool for drawing arches. Test different circles of a template until the arc of one circle connects the top of the bottom arch line with the two edges of the window or door frame. Use a larger circle to draw the top arch line.

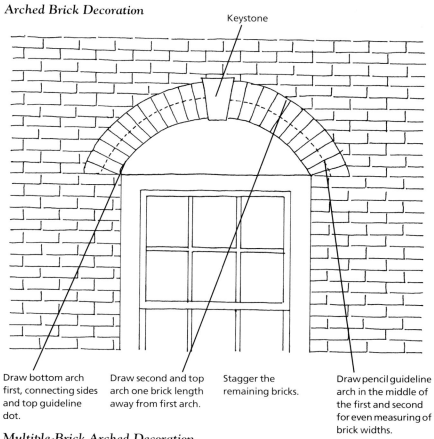

Arched Brick Decoration

Keystone

Draw bottom arch first, connecting sides and top guideline dot.

Draw second and top arch one brick length away from first arch.

Stagger the remaining bricks.

Draw pencil guideline arch in the middle of the first and second for even measuring of brick widths.

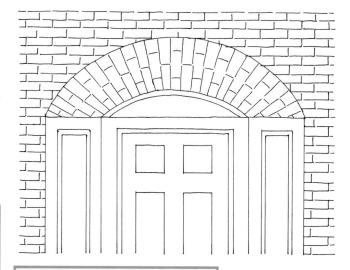

Multiple-Brick Arched Decoration

Problem: At what angle should each brick be tilted?

Solution: Draw each line at a 90° angle from the lower arc guideline.

BRICK COURSE

A *brick course* is a continuous, level, horizontal range of brick or masonry that often interrupts the established brick pattern of a wall. Some designs jut out from the face of the wall below the windowsill and cast a shadow. Ink a narrow stretch of diagonal lines just below the brick course.

Another type of brick course found in older homes may be flush with the wall and serves to interlock the brick wall with a structural base. While not as obvious, this course is a subtle variation in the brick face and you should render it faithfully.

Decorative Brick Course

Structural Course

Decorative course with shading.

Structural course

BRICK QUOINS STEP BY STEP

Quoins are blocks used on corners. The shadows of their jutting shapes add a decorative effect to a wall.

1 Place your quoins.

On your photo, count the number of quoins on the wall. Draw *pencil* guidelines on the edge of the wall to divide the space for quoins just as you do for siding. Draw a vertical *pencil* guideline indicating the width of the quoins on the inside edge. On some homes, they are the same from top to bottom; on others they alternate wide and narrower. Except for quoins, pencil the brick guidelines on the wall and ink them.

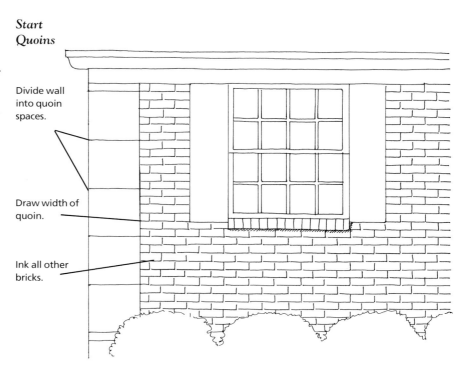

Start Quoins

Divide wall into quoin spaces.

Draw width of quoin.

Ink all other bricks.

2 Finish the quoins.

In *pencil* first, subdivide the quoins into full-height rows of bricks, including the spaces between rows. Draw, then ink the outside edges of the quoins jutting beyond the wall, leaving the space between them at the wall edge. Mark the individual bricks on and below the quoins with *pencil* and then ink them.

 Ink a narrow line of diagonal strokes under each quoin and on its vertical edge away from the sun for shadows. On very small house portraits, use a heavy ink line instead of short diagonals.

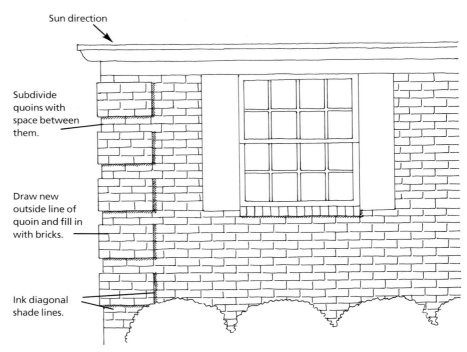

Finish Quoins

Sun direction

Subdivide quoins with space between them.

Draw new outside line of quoin and fill in with bricks.

Ink diagonal shade lines.

STONE SIDING STEP BY STEP

Many builders now incorporate an occasional stone wall for siding, combining it with clapboard for interest and contrast. You do not have to depict every single stone in excru- ciating detail, unless you really enjoy drawing that way and have the time. The ultimate effect of variety and scale of this decorative siding is what counts.

1 Study your photos.

Find any patterns in the stone siding, such as wide-thin, series of vertical, series of horizontal, etc. Look at wall edges and window framing to find a reliable starting point.

> **HELPFUL HINT**
> *for Establishing the Scale of Stones*
>
> Compare the largest stone to a nearby window pane, coach lamp or other measurable object.

Stone Siding Makes a Statement

2 Draw largest stones first.

Draw the largest stones, then others in relative sizes and shapes. If you have not already done it, *pencil* vertical and horizontal guidelines for the wall edges enclosing the siding. Where there is no apparent pattern, draw in *pencil* the largest stones in their proper space on the wall first, then locate others around them in their relative sizes and shapes. Be sure to depict the oddly shaped stones and the especially large ones, but others you may fill in without trying to replicate the mason's precise design.

3 Ink the stones.

Ink each stone freehand.

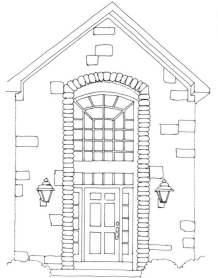

Place Large Stones First

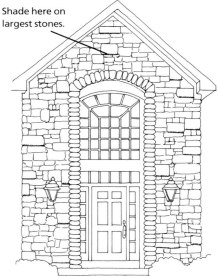

Shade here on largest stones.

Shade on Largest Stones

MANUFACTURED CONCRETE STONE STEP BY STEP

There is usually a discernible pattern to the stones in this type of wall. The height of each one is proportional to each and every other block. The total number of horizontal guidelines would be how many of the narrowest blocks, in height, fit into that space.

1 Draw horizontal guidelines.

Using the space division technique described in chapter three and using your T-square, draw in *pencil* every horizontal line that divides all the stones into their multiples.

2 Draw the blocks.

Draw the blocks in pencil and then ink. With your close-up photo as a critical reference on the drawing table, draw the lengths of the first row of blocks in *pencil*. Draw the vertical block ends included in that row to a height of one, two or three guidelines, as your photo shows. Work across the row and down, relating the width of blocks to the windows and/or blocks above. Freehand ink your concrete stone blocks, remembering that the hand-drawn horizontal line actually enhances the rough edges of this siding.

3 Ink the texture and shading.

Erase your guidelines and add varying heights of short diagonal ink lines to show the texture and shading of the stone as revealed by the shadows in your reference photo.

Subdivide Manufactured Stone Space

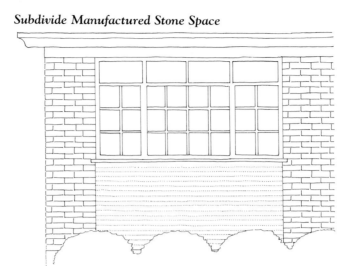

Block Alignment

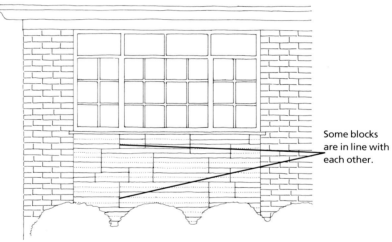

Some blocks are in line with each other.

Shade Irregular Stone Surface

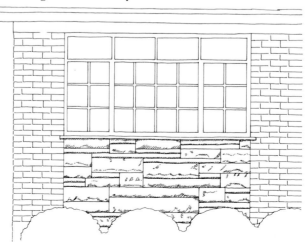

BOARD-AND-BATTEN SIDING

This type of construction forms the exterior wall with side-by-side vertical boards and smaller, very narrow boards, or *battens*, placed over the seams. The shadows cast by battens add a decorative pattern to an otherwise plain wall and convey an upward movement of the eye in the American wooden Gothic style of architecture.

In *pencil*, in a small 6″ × 9″ (15cm × 23cm) drawing, draw battens with the one line of shadow cast on the wall. Notice that the shadow under the eaves on the batten is narrower than on the board because it juts out into the sun. Drawing this detail gives the batten definition.

In a larger drawing, draw battens with two lines evenly spanning the pencil guideline.

Shadow on Batten

Make narrow shadow on batten.

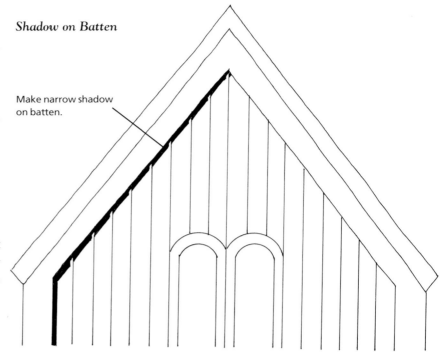

Ink Shadow Side

Ink shadow side with a 0.50mm nib pen or two lines next to each other.

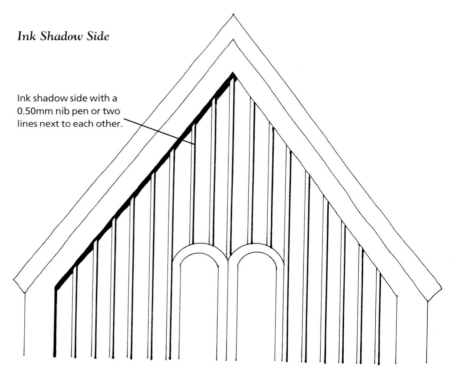

HALF-TIMBER SIDING STEP BY STEP

Often referred to as *Tudor style*, half-timber construction offers a striking contrast of dark heavy beams with a stucco wall. Deep eaves produce shadows for a three-dimensional effect. Curved beams can be daunting to draw, but there is a rhythm and order to their placement.

1 Draw outlines.

Draw in *pencil* the roof, eaves and the heaviest horizontal beams, followed by the center vertical timber and windows. Simplify the drawing by erasing the lines where beams intersect. The structure does not need strong definition here, and you will later shade these areas with short diagonals.

Draw the curved beams in *pencil*. Use a large circle template or French curve (found in art and drafting supply stores) to connect the base to the upper sides. Draw all the other vertical boards.

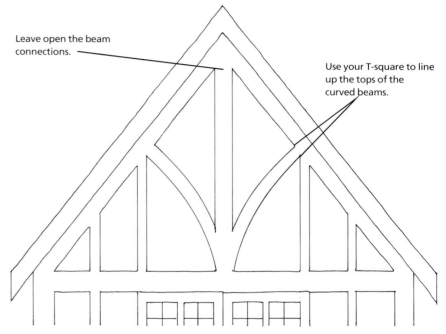

English Tudor Half-Timber Siding

Leave open the beam connections.

Use your T-square to line up the tops of the curved beams.

HELPFUL HINT
for Using a French Curve

When you use a French curve to draw symmetrical lines going in opposite directions, mark the beginning and end of the first line with pen on your plastic curve. A fine pen line easily marks plastic, and you can quickly wipe it off with tissue when done. Flip it over for the opposite curve, then line up those marks with the beginning and end points on your drawing. Now you will not have to guess endlessly, the way I did, where on that variable curve you drew your first line.

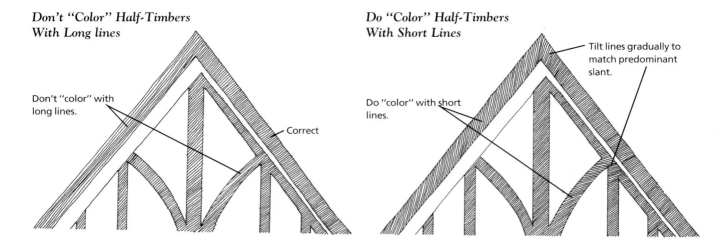

Don't "Color" Half-Timbers With Long lines

Don't "color" with long lines.

Correct

Do "Color" Half-Timbers With Short Lines

Tilt lines gradually to match predominant slant.

Do "color" with short lines.

2 Ink the pencil lines.

Ink over all pencil construction lines. Freehand ink with diagonal lines all the beams in direct sun to convey a sense of the dark wood, reserving black to serve as shadows later. Let one diagonal roofline dictate the degree and direction of slant on all vertical and horizontal beams. Shade peaks and curves by gently changing the slant on curves and peaks to keep the lines short.

> **HELPFUL HINT**
> *for Inking Long Beams*
>
> Draw a few pencil guidelines on the long beams to help you keep your slanting lines regular.

Shade Half-Timbers and Stucco

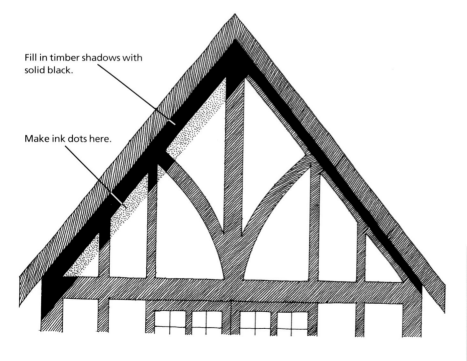

Fill in timber shadows with solid black.

Make ink dots here.

3 Ink the shadows.

Ink shadows to accentuate textures and suggest depth. Draw a *pencil* guideline for the stucco shadow area, and then ink evenly spaced small dots.

> **HELPFUL HINT**
> *for Shading*
>
> Do not let the direction of the shading lines become parallel to the shape, or you will confuse the structure with color. Besides, they are hard to keep uniform in distance. Mine wiggle and look awful.

WINDOWS STEP BY STEP

Just as eyes reveal human personality, windows give character to a home and often express the owner's unique taste. Now that you have grasped the fundamentals for dividing space, such as the siding described in chapter three, you can draw any kind of window with a few adjustments.

Double-Hung Sash

1 Draw the window frame outline.

Draw the outline of your window frame in pencil. Use your T-square and triangle. Notice that the bottom of the frame is widest. Count the panes and their pattern. Let's say there are twelve panes, six in each sash.

Find the middle of the window using the 10 scale on your engineer's ruler, placing 0 on the bottom edge and any number clearly on the top edge of the inside window frame. Place a dot on your paper at the midway point. With your T-square, draw a horizontal line on each side of that dot.

HELPFUL HINT
for the Math-Challenged Artist

Angle your ruler to position the scale directly on an even number. You may have to extend either the top or bottom edge outside the window frame. It's easier to find the halfway mark between the beginning and an even number (1 and 6) than with odd numbers (1 and 7) or increments of whole numbers (1 and 5.5).

Double-Hung Sash Windows

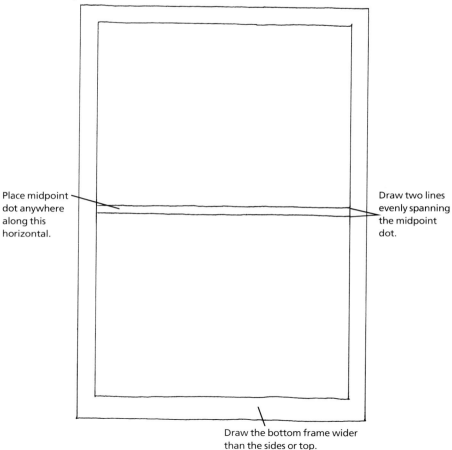

Place midpoint dot anywhere along this horizontal.

Draw two lines evenly spanning the midpoint dot.

Draw the bottom frame wider than the sides or top.

2 Begin the mullions.

Measure the top half and bottom half between frames and mark a dot in *pencil* midway between those points on the 10 scale. With the T-square, draw a single horizontal line through each of those markers.

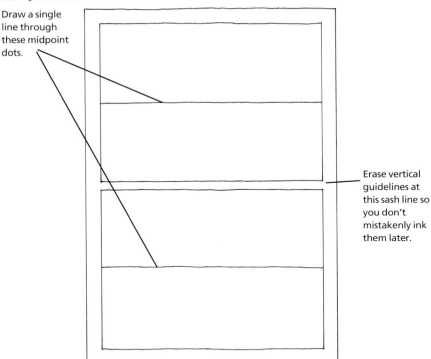

Horizontal Mullions

Draw a single line through these midpoint dots.

Erase vertical guidelines at this sash line so you don't mistakenly ink them later.

3 Divide the space.

Divide the side-to-side space into thirds. Measure from one vertical side to the other, extending one side edge if needed, to a number on the scale easily divisible by three, such as six or nine. Mark your window space along the diagonal and draw the vertical divisions in pencil with the triangle resting on the T-square.

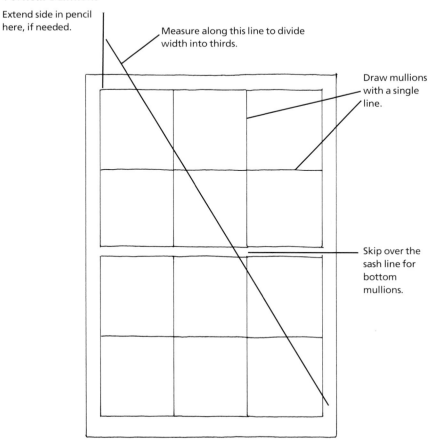

Vertical Mullions

Extend side in pencil here, if needed.

Measure along this line to divide width into thirds.

Draw mullions with a single line.

Skip over the sash line for bottom mullions.

4 Add ink and final touches.

Use your T-square and triangle for the vertical lines, and freehand ink the horizontal lines. Trust yourself to ink a narrow mullion by making a line on both sides of each guideline. You can make minor adjustments in this step when the guidelines may not perfectly divide the space rather than redrawing those guidelines in pencil. Simply suggest the lapping of the top sash over the bottom by extending the bottom sash line slightly into the frame on each side.

> **HELPFUL HINT**
> *Time Saver From a Pro*
>
> Ink all of your vertical mullion lines, stopping short of the horizontal guidelines and skipping over the window sash line. Then position your paper comfortably to ink the horizontal mullions freehand.

Problem: Getting uniformly sized panes when there is an uneven number of horizontal rows, such as 5.

Solution: Angle your ruler to go just beyond the easily divisible by five number in an amount that equals the width of your sash shown by line AB. Notice that the endpoint B is above the frame line by an amount equal to the width of the sash.

1 Mark the horizontal lines numbered 1 and 2, and draw them in *pencil* using your T-square.
2 Draw the sash width below line 2.
3 Reposition your ruler below the sash to the bottom inside frame, shown as line CD. Mark your spaces numbered 3 and 4. Draw those horizontal lines.

Finishing Mullions

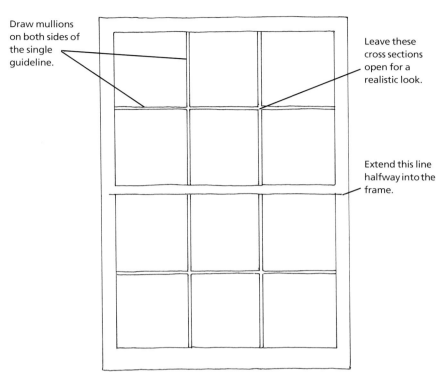

Draw mullions on both sides of the single guideline.

Leave these cross sections open for a realistic look.

Extend this line halfway into the frame.

Odd-Number Mullion Divisions

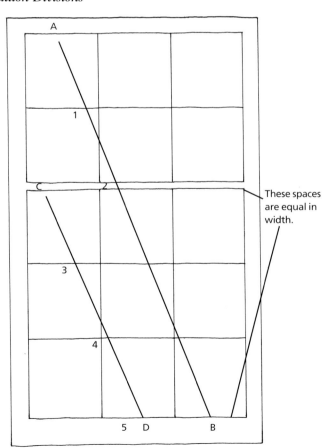

These spaces are equal in width.

Casement

These steel frame windows were easy to install and simple to operate back in the 1940s when a small housing boom flourished in America. They opened outward on hinges and closed snugly with a friction latch. For the homeowner in the winter, however, these windows were a constant source of irritation. Heavy condensation rusted the frames and actually dripped puddles onto sills, requiring frequent painting. Eventually, fuel economy and prospects of easier maintenance prompted many owners to replace air-leaking steel casements with well-sealed vinyl frames and double glass.

Replacement Window

Fixed picture window

These side units slide toward the center.

Casement Window

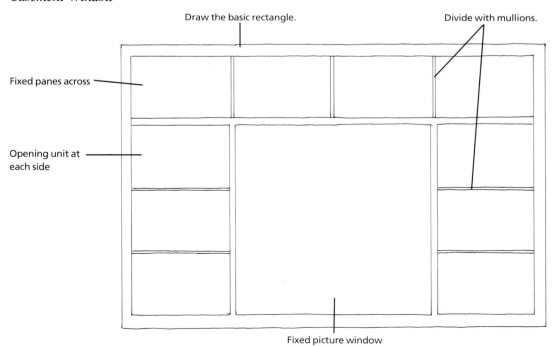

Draw the basic rectangle.

Divide with mullions.

Fixed panes across

Opening unit at each side

Fixed picture window

A variation on the casement style, common to half-timbered homes, has smaller panes and often two operating units within the same frame. You can spoil the decorative effect of many small panes throughout the face of the house by trying to add curtains, unless the owner insists. If I have my way, I shade all the mullions with diagonal lines and the panes are black.

Problem: How to make a window look open.

Solution: Draw it as you would draw the side of an angled house. The most sharply angled lines will be the top and bottom of the frame. The mullions will be slightly less angled but different from each other.

Open Window

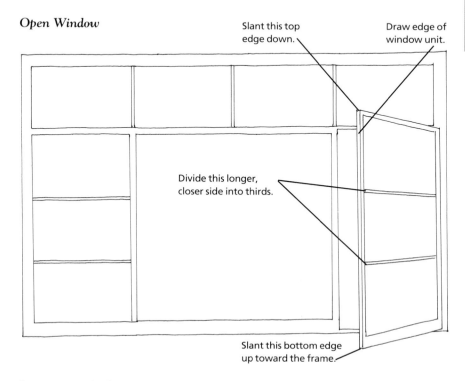

Slant this top edge down.

Draw edge of window unit.

Divide this longer, closer side into thirds.

Slant this bottom edge up toward the frame.

Separating Black Panes

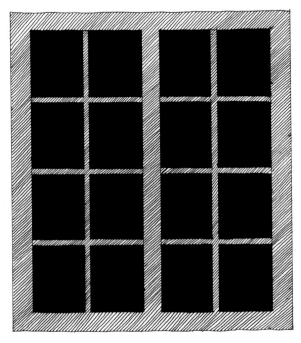

Shade frame and mullions with slanted ink lines to separate the black panes.

Leaded-Glass Windows

Often found in half-timbered homes, the decorative diamond design of leaded-glass windows just a matter of dividing space as you learned in chapter three. A simple design of four full diamonds vertically and two horizontally, split half-whole-half, will demonstrate the basic steps.

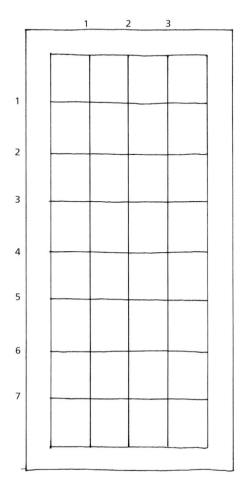

1 Pencil a grid.

Represent lines through each point where diagonals intersect. Number the lines across and down.

CAUTION
for Watercolor Paper

Since pencil lines are hard to fully erase from watercolor paper, do not draw the grid lines. Instead, mark just the inside edges of the window frame with the grid line guides. Draw a rectangle on graph paper with the proper number of grid lines. Number them and draw your first diamond as a model for where to start the diamond on the watercolor paper.

2 Draw center diamonds.

Draw the center diamonds in *pencil*, top to bottom. Start at the top point of the center vertical line (2) at the edge of the frame. Continue down, with the diamonds meeting point to point on rows 2, 4 and 6 and the wide points of the diamonds resting on the vertical grid lines 1, 3, 5 and 7.

Grid

Leave open at each point.

3 Draw half diamonds.

Draw half diamonds on the sides using grid lines. If you have drawn your grid precisely, you will see that you can simply extend the lines from the whole center diamonds all the way to each inside frame edge.

4 Ink the diamonds freehand.

Use double lines, one on each side of the diamond guidelines. Let the crossing lines remain open. You will fill in the panes later with watercolor or ink. Carefully erase your grid and all guidelines.

Jalousies

These have been popular as year-round storm doors. The adjustable glass louvers allow fresh air to circulate in the warm seasons, yet they can be easily closed when cold air is not welcome. You can also see louvers on sun porches converted for winter use. Since the bottom edges of overlapping glass panels are barely visible, I use a dotted instead of a solid line. Suggest each louver's slightly outward slant with a shadow on each one at the inside frame edges.

Inking Louvers

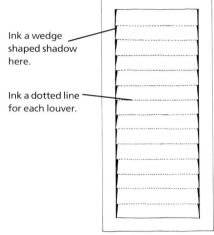

Ink a wedge shaped shadow here.

Ink a dotted line for each louver.

HELPFUL HINT
for Showing Curtains

To show a curtain in a window, just ink the diamonds with single lines that cross over each other.

SHUTTERS

Shutters are functional in cold blustery climates and in the tropics alike, protecting all within against weather extremes. In newer construction, they tend to be simply decorative and may not even frame a window. Two might just stand guard at the sides of the front door. Some shutter colors pose problems for the pen-and-ink artist, such as low contrast against the background. Their small size sometimes makes shutter details hard to render with good results.

Functional Shutters
Closely observe these functional details and photograph or presketch them if necessary: the bar that moves the louvers, the inside latch and the holding device on hinged shutters of a historical New England home.

Decorative Shutters
These are often narrower than half the window and fixed on the walls.

Historic Home Shutter

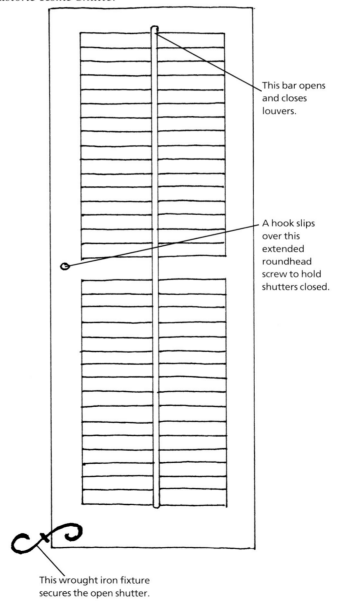

This bar opens and closes louvers.

A hook slips over this extended roundhead screw to hold shutters closed.

This wrought iron fixture secures the open shutter.

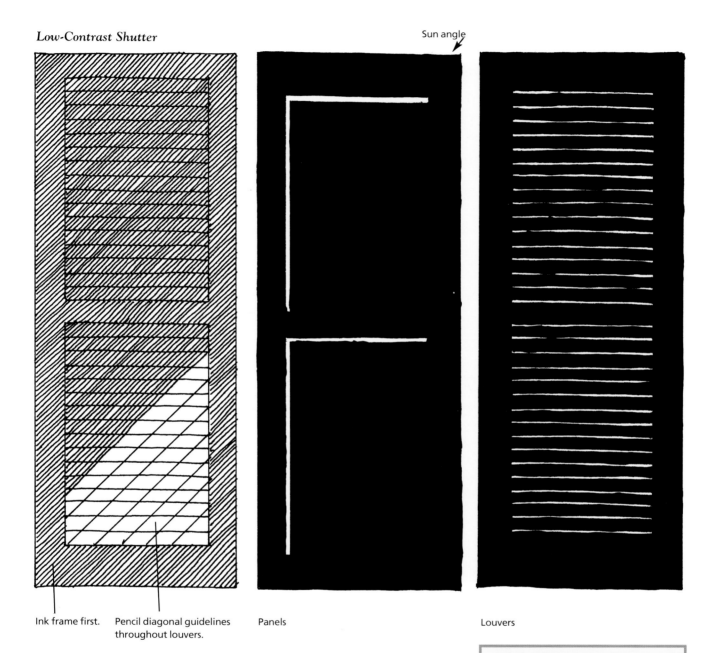

Low-Contrast Shutter

Sun angle

Ink frame first.

Pencil diagonal guidelines throughout louvers.

Panels

Louvers

Problem: Shutter is solid black and hides the shutter pattern.

Solution: When inking, leave a thin white line suggesting how the sun hits the panels.

Problem: Contrast of shutter against background is hard to discern.

Solution: Hold your photo at arm's length, and squint your eyes so the shapes are somewhat blurred. Ask yourself which is lighter: shutter or background? Think black, white or gray.

White Shutters

In defining all the louvers or panels of white or light-colored shutters you are actually adding "color." The key is to reduce the number of ink lines needed to define the shutter pattern.

Problem: Shutters or louvers seem to be the same color as the brick wall.

Solution Keep your brick as light as possible using the technique described earlier in this chapter (see page 63), and depict shutter color with diagonal lines. Show louvers by leaving a thin white line on each jutting edge.

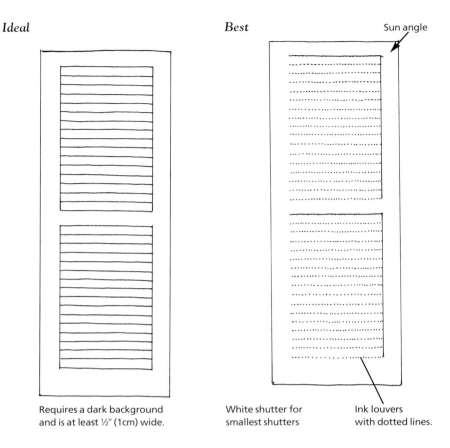

Ideal

Requires a dark background and is at least ½″ (1cm) wide.

Best

Sun angle

White shutter for smallest shutters

Ink louvers with dotted lines.

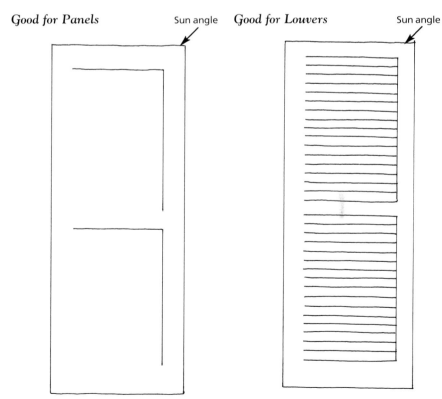

Good for Panels

Sun angle

Good for Louvers

Sun angle

WINDOW INTERIORS

House portraits of a minimum 12″ (30cm) width provide room to customize the window interiors as they really appear. A sampling of window enhancements follows, giving you a vocabulary to help clarify what you see in your close-up photos, as well as any discussions needed with the owner.

Drapes

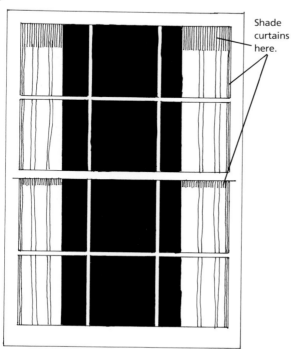

Shade curtains here.

Sheers

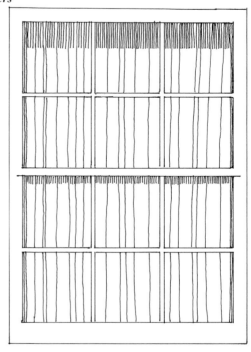

Café Curtain With Valance

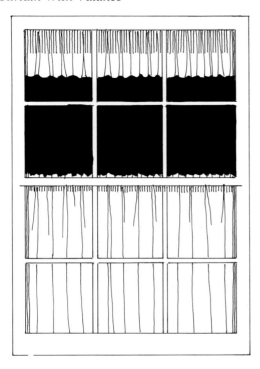

Drapes With Window Shade

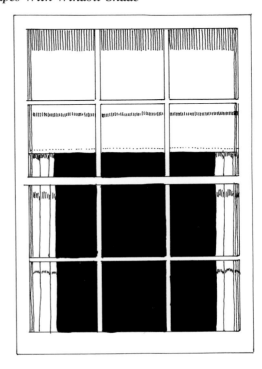

Ruffled tie-back at sill

Roman shade

Jabots and swag

Lace curtain

Balloon valance

Wood shutters

Picture window with sheers and tie-back drapes

Closed venetian blind

Open mini-blind

DOORS

Front doors may seldom be used, but they are designed as the main gateway to life inside and ought to be the focal point of the house portrait. When a storm door obscures the more attractive primary portal, I'll try to persuade the owner to let me omit the outer door. A few samples are shown to suggest what you should look for and sketch on-site or photograph as close-ups.

Solid Doors

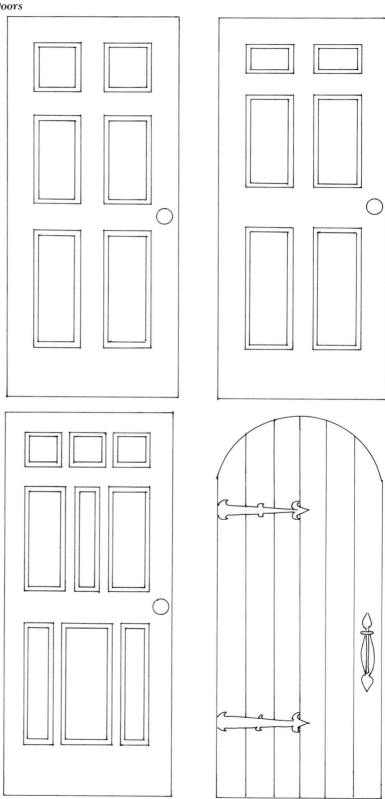

Door Windows

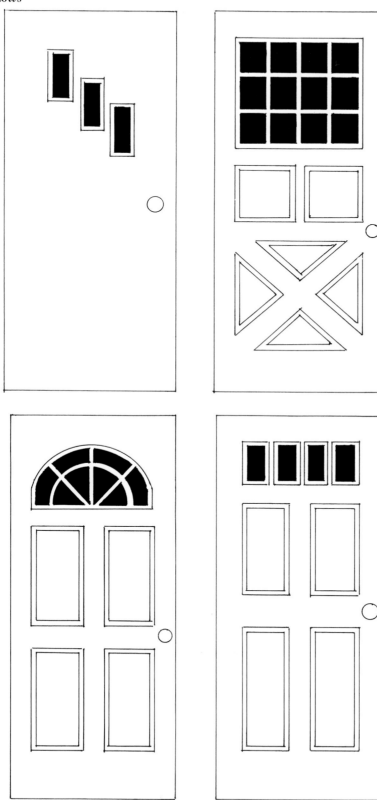

Large Entries

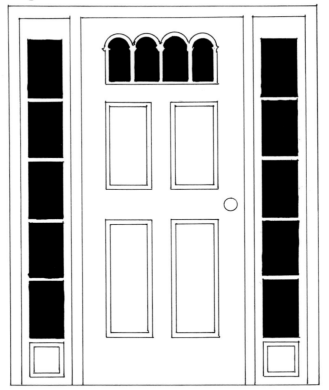

Side windows and double doors connote a large interior entryway.

Draw just the shadows of intricate paneling where there is strong sunlight.

GARAGE DOOR STEP BY STEP

A simple overhead garage door is a large, blank rectangular space that needs something to artistically interrupt it. If it has only horizontal divisions where the panels hinge when opening, you can measure, draw and ink them just as you would for siding and be done with them. Decorative panels are a legitimate way to interrupt that otherwise unimportant, eye-riveting space, but they do present a challenge.

Basic Grid

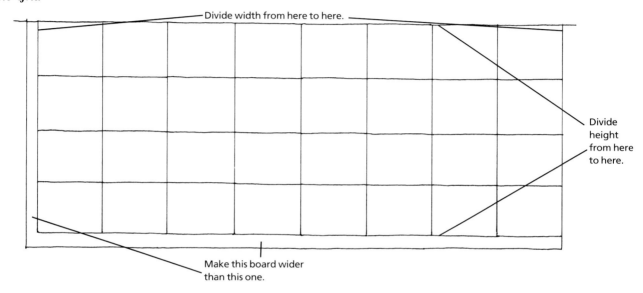

Divide width from here to here.

Divide height from here to here.

Make this board wider than this one.

1 Draw a grid.

Draw your grid pattern in pencil. Let's say there are eight columns of panels and four rows. Think of it as a big window. The boards on the bottom and sides are like a window frame.

Draw the bottom board first, followed by one narrower board on the left side. You do not need a top board or board on the right at this time. In this case, divide into four even rows from the bottom board to the top of the door. Divide into eight columns vertically from inside the narrow left board to the right-hand edge. Pencil in that simple grid lightly using your T-square and triangle.

Completed Grid

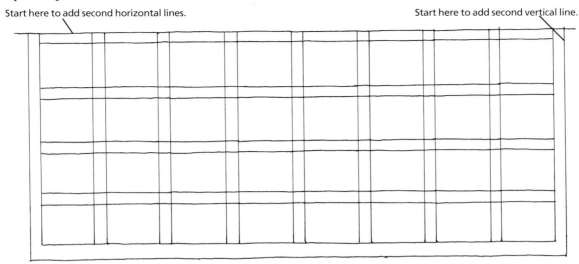

Start here to add second horizontal lines.

Start here to add second vertical line.

2 Draw basic rectangles.

Draw a second line below and to the right of each grid line. In a width equal to the side frame, draw a second line below each of the horizontal grid lines, starting at the top of your garage. Starting at the right ga-rage edge, add a second line to the right of each vertical grid line, again the same width as the side frame. Now you have the basic rectangles for your decorative garage door.

Shadows

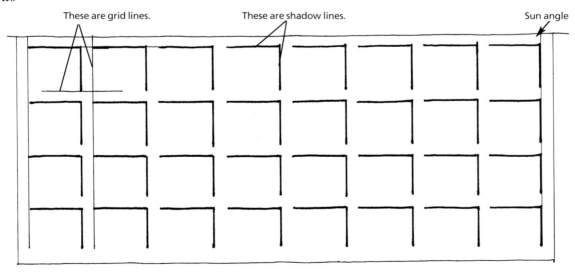

These are grid lines.

These are shadow lines.

Sun angle

3 Ink in shadows.

Ink shadows inside grid lines. This is a low-key way to define simple raised or indented panels without calling a lot of attention to a less important part of your house portrait.

ROOFS STEP BY STEP

Simple shingled roofs are seen frequently throughout the United States and are illustrated in chapter three. Tile roofs, common in southwestern states, and others such as slate, metal and thatch, deserve mention for their decorative qualities. Each may appear difficult at first, but if you follow along, step by step, you'll be able to draw them successfully.

Slate

Slate is actually thin rock that is skillfully cut into slabs. Think of very wide, but thin, bricks laid on a slanted surface.

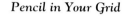 **1** Draw a grid.

Make a grid in pencil. Using your space-dividing skills, mark the eave line with intervals for reasonably sized slates across, say twenty-three for this example. Place your triangle on the top roofline with the right-angle corner resting on the left roof corner. Extend the vertical edge of the triangle into the sky.

Lay the 0 point of your engineer's ruler on the right roof corner, and make a diagonal line where the number 23 intersects with the vertical line. Make small slash marks on the diagonal line at every number from 1 to 23. With your T-square firmly in place on or near the eave line and your triangle resting on it, connect each slash mark on the diagonal with the top roofline and make a small slash mark on the roof.

Pencil in Your Grid

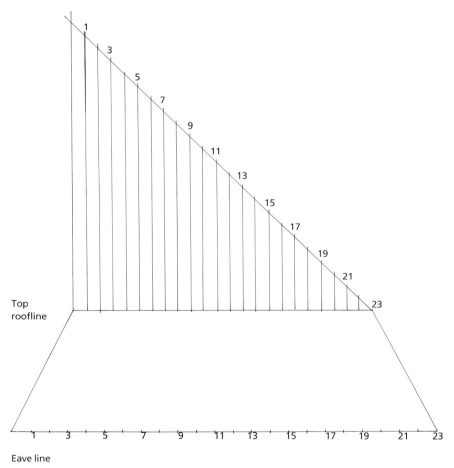

Continuing with *pencil*, draw the slanted vertical line that connects each slash mark on the top roofline with its mate on the eave line.

With T-square and pencil, draw horizontal lines from top to bottom, increasing width as they near the eaves.

First Grid Guidelines in Pencil

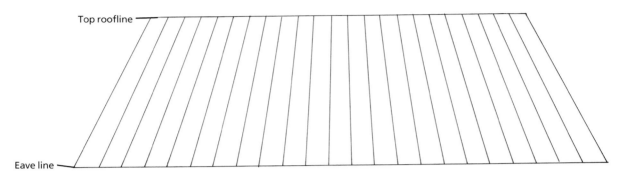

Top roofline

Eave line

Completed Pencil Grid

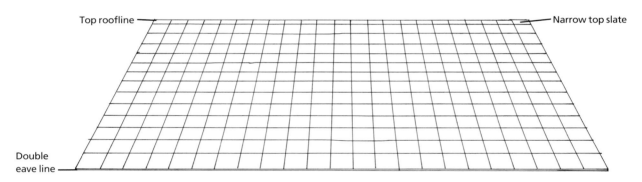

Top roofline

Narrow top slate

Double eave line

Draw a Slate Roof

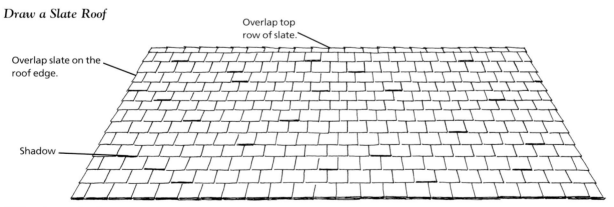

Overlap top row of slate.

Overlap slate on the roof edge.

Shadow

2 Ink each slate.

Do this similar to the way you ink the lightest colored bricks, as described earlier in this chapter (see page 63). Ink every other horizontal row first, then ink upright on the slanted grid guidelines. As an extra touch in a large house portrait, randomly underline a number of slate slabs to indicate shadows on the ones below.

TILE ROOF STEP BY STEP

Curved tiles on the top of the roof and along each hip and their half-cylinder shape on the roof body distinguish this from other roof styles. The pencil grid design enables you to render the overlapping tiles merely by defining their shadows. The final inking is really the easiest part.

Begin the Grid for a Tile Roof

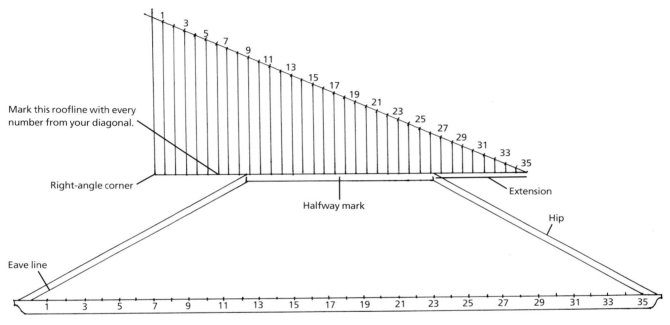

1 Begin your pencil grid.

Draw your roof in *pencil* exactly as your photograph shows, including the tile top and sides or "hips." Divide your eave line into tile segments and number every other one. Let's say there are thirty-five tiles; thus you need thirty-five spaces.

Divide your top roofline in half and extend your top roof edge horizontally by that same half measure-ment on each side (for example, if the top of your roof is 2″ (5cm) wide, extend a 1″ (3cm) line on either side of the roof). Rest the right-angle corner of your triangle on the left endpoint of the rooftop extension, and draw a vertical line into the sky.

With the 0 of a ruler or engineer's scale located on the right endpoint of the rooftop extension, draw a diagonal line in *pencil* from 0 to the vertical line where a count of thirty-five connects with it. Pencil each of the thirty-five marks on your diagonal and number every other one. With your triangle resting on the T-square, draw the slanted vertical line from each mark on the diagonal to the top edge of the roof, including its horizontal extensions.

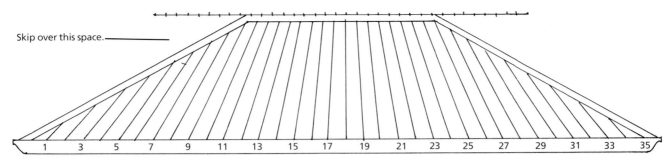

Skip over this space. ————

| 1 | 3 | 5 | 7 | 9 | 11 | 13 | 15 | 17 | 19 | 21 | 23 | 25 | 27 | 29 | 31 | 33 | 35 |

Complete Pencil Grid

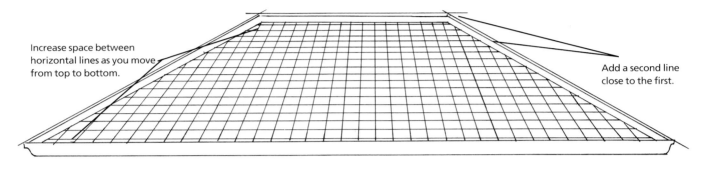

Increase space between
horizontal lines as you move
from top to bottom.

Add a second line
close to the first.

Finished Tile Roof

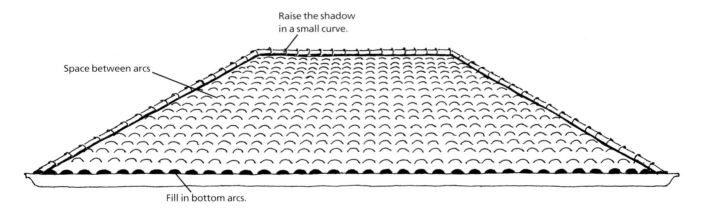

Raise the shadow
in a small curve.

Space between arcs

Fill in bottom arcs.

2 Complete your pencil grid.

In *pencil*, connect each top roof tile
line with its corresponding mark on
the eave, using the numbered ones
to guide you, and draw only within
the actual rooflines.

Using your T-square, draw your
horizontal lines so that they grow in-
creasingly wider from the top to the
bottom. Add a second line close to
the existing one on each hip and top
roofline.

3 Pencil in tiles and ink your roof.

In *pencil*, draw a narrow arc spanning
each grid space on every row. Draw
a slight curve to show the length of
tiles on the hips and top roof. Free-
hand ink your tile arcs, leaving small
gaps at the slanted vertical grid
lines. On the hip and top roof edges
leave little gaps between the tile
lengths to indicate the sun.

METAL ROOF STEP BY STEP

You will often find barns, old farm homes, porch and bay window roofs made of overlapping metal panels with jutting seams. They can be painted, shiny or simply dark metals like copper. Whatever their finish, the decorative effect of the sun casting a shadow from their raised seams is worth replicating.

1 Make pencil guidelines.

In *pencil*, mark the eave and the rooftop with the number of sections shown in your photo. Connect them with a narrow double line, one line on each side of your markers.

> **TIP**
> *for Keeping Lines Straight*
>
> With your pencil and T-square, draw several horizontal guidelines every ¼" (0.6cm) through the whole roof area.

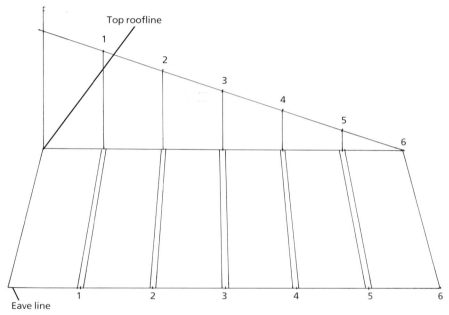

Pencil Grid for a Metal Roof

Top roofline

Eave line

2 Ink your roof.

Ink the roof side edges with dotted lines, as first described in chapter three's pen-and-ink house portrait demonstration. When inking the top roofline, raise overlapping seams with a small arc.

With a 0.5mm pen point, ink the shadow side only of the seams. If your roof is unpainted and shiny or if you plan to add watercolor later, your roof is now finished.

If your roof is a dark color, free-hand ink narrow horizontal lines between the heavy shadow line and the pencil guidelines. Erase the guidelines.

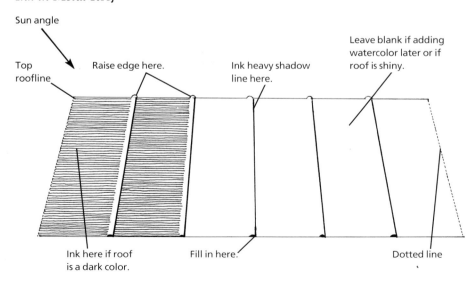

Ink in Metal Roof

Sun angle

Top roofline

Raise edge here.

Ink heavy shadow line here.

Leave blank if adding watercolor later or if roof is shiny.

Ink here if roof is a dark color.

Fill in here.

Dotted line

Thatched Roof

Restoring historic structures bearing a thatched roof is contributing to a revival of skilled artisans. We artists need to find ways to show the texture of this densely packed roof without drawing every stick of straw or reed. Shadows are a good route to simplicity.

A simple roof covers a flat surface and curves over the top. Draw the deep overhangs and show their shadows. A more complex thatched roof mounds over dormers and is likely to have an artistic design of a carved top overlay.

Draw a Thatched Roof

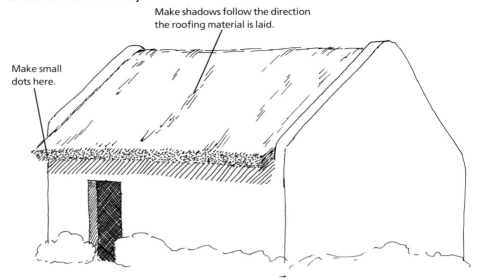

Make shadows follow the direction the roofing material is laid.

Make small dots here.

Finished Thatched Roof

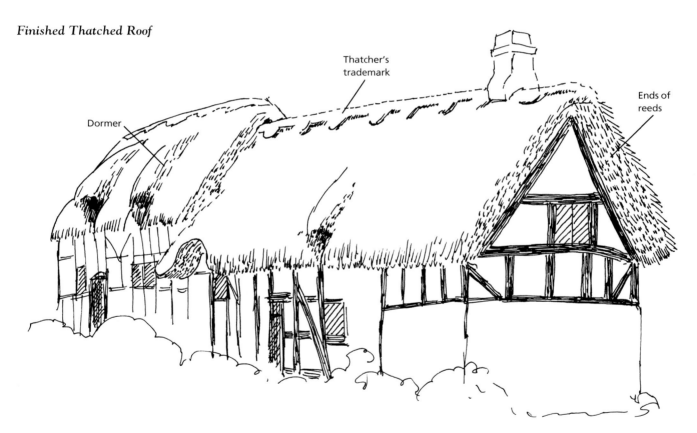

Thatcher's trademark

Dormer

Ends of reeds

EAVES AND PEAKS

You need good photo close-ups and patience to draw the complex brackets and the fancy peaks of Victorian-era homes. Using your circle template, T-square and triangle, make a larger-than-needed practice pencil drawing of one bracket and one side of the peak. Once you have those designs clearly imprinted in your mind through an actual drawing, you will make credible repetitions, and the owner will marvel at your skillful rendering.

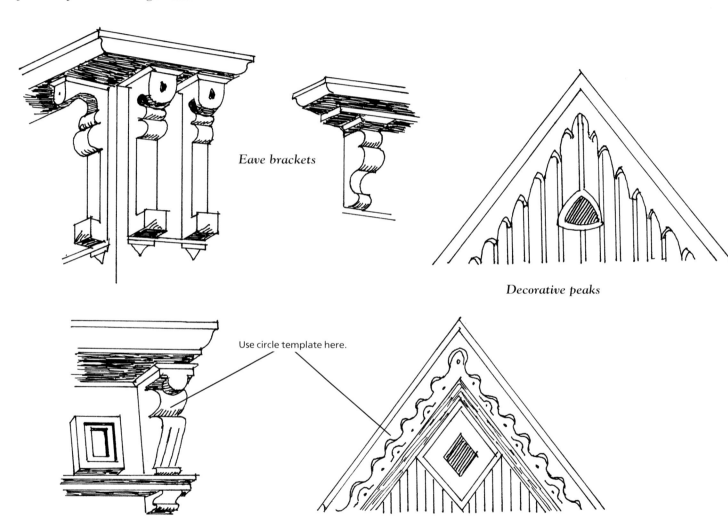

Eave brackets

Decorative peaks

Use circle template here.

PORCHES

Porches provide practical protection from the elements, and they also provide an attractive diversion from the otherwise flat front of the house or church structure. Variations in support range from solid stone, brick and wood to the lacy design of wrought iron.

Round or flat tapered columns can be vexing to draw realistically, and wrought iron demands more detail than we might want to depict, but a few tips in the pencil-drawing stage will ease the process.

Tapered Columns

1. Draw basic porch structure in pencil.

2. Measure from center to center of each column on your photo, and draw vertical guidelines with triangle and T-square.

Draw Tapered Sides

1. Measure column widths at the top and bottom on photo.

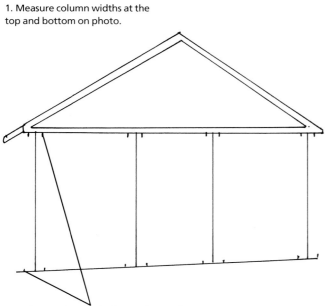

2. Make pencil marks half on each side of center guideline top and bottom.

1. With straightedge, connect top to bottom. Erase center guideline.

2. Add block features top and bottom.

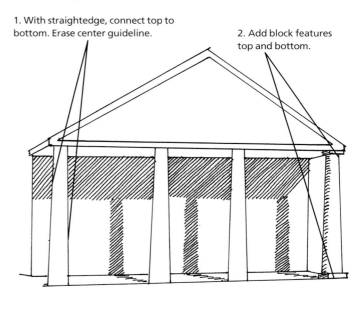

3. Add shadows under the porch roof and on the columns in the final inking or watercolor.

Wrought Iron Porch Support

When wrought iron is black, your ink lines show the pattern. When wrought iron is painted white, black lines cannot be used to define the pattern, so simplify the pattern in order to draw double lines, leaving the white space to contrast with the dark background of the porch shadows. Draw dotted lines to suggest intricate grillwork.

Problem: In a small house portrait, 6" (15cm) high by 9" (23cm) wide, there is not room to draw all the smallest details.

Solution: Simplify the design, leaving out the less important lines.

Wrought Iron Support

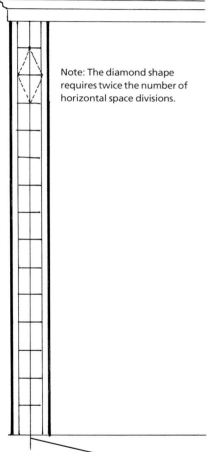

Note: The diamond shape requires twice the number of horizontal space divisions.

1. From your photo, measure and draw height and width of porch support in pencil.

3. Draw center guideline in pencil.

2. Divide space evenly top to bottom, enclosing each repeated design figure.

Black Grill Work

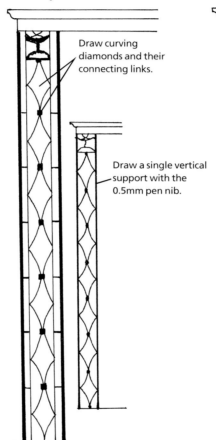

Draw curving diamonds and their connecting links.

Draw a single vertical support with the 0.5mm pen nib.

TIP
for Shaping Curving Diamond Lines

Use your circle template.

White Grill Work

RAILINGS AND FENCES

Although subordinate to the house, the repetitive design of railings on porches and fences in the yard are an opportunity to customize the house portrait. Even the utilitarian chain-link fence can evoke the nostalgic memory of a precious child or pet. Use your space-dividing skills.

Chain-link

Wood or stone

Split rail

Wrought iron

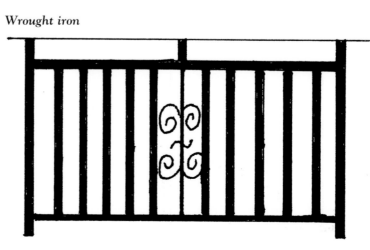

Wood deck

Lattice

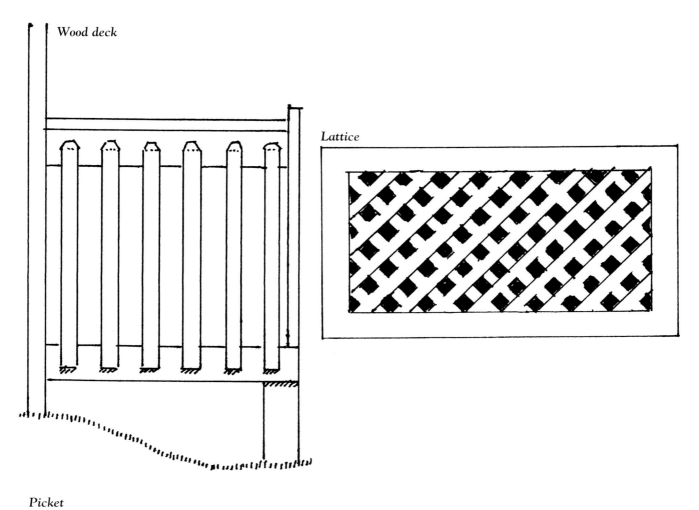

Picket

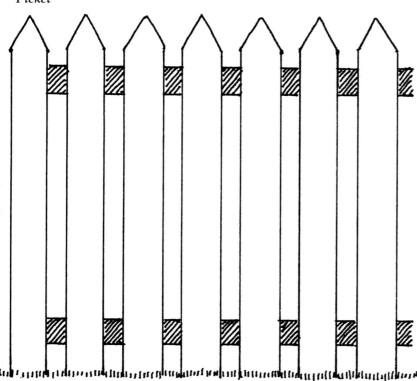

MAKING HOUSE PORTRAITS A HOME BUSINESS

Making money, a little or a lot, shifts the focus away from pleasing just yourself with your hobby. Knowing clearly why you want to make money keeps you motivated, and following solid business practices will give you, the entrepreneur, a good start. Perseverance and being an alert listener to your clients will give you ideas about how to improve your business.

YOUR STUDIO IS YOUR PLACE OF BUSINESS

Dedicated studio space nurtures a professional attitude. If you have to move stuff off the kitchen table to do your artwork, you'll soon be frustrated by distractions. You are a professional now and need to nurture a business-like attitude for yourself.

People used to laugh when I would describe my first stark studio as an art-only card table next to a window in one corner of the second-floor finished attic of my home. After several years of commissioned work, I had saved enough money to buy a real drawing table. What a joy and satisfaction it is today!

MARKETING

Marketing is the process of selling your product, including targeting your efforts to those most likely to buy it. Why do people buy house portraits? Nostalgia echoes in the following reasons:

"This is my dream (or very first) home."

"My grandmother is moving out of her home of forty years."

"My husband grew up here."

Other buyers need gifts: Realtors for their clients at the closing, office workers for their boss, siblings for their parents or church members for a departing pastor.

Is This for You?

See how you do on this little quiz. Are the following questions true or false?

1. Everybody wants a house portrait.
2. You are a good artist.
3. Basic tools are a big investment.
4. Word of mouth is the only advertising needed.
5. The customer is always right.
6. Records are important.
7. House portraits are fine art.
8. You need a full-blown studio.

Numbers 1, 3, 4 and 8 are correctly answered "false." Numbers 2, 5, 6 and 7 are correctly answered "true."

Promotion and Exposure

Advertising and promoting your work snares the buyer's attention. Word of mouth is good advertising and might support your passion for snack food, but early in your career you will need a broader base of public exposure to your talent. Following are some ways you can promote your work and gain exposure.

Design a Business Card and Brochure

Give your house portrait business a name and design a logo. Have business cards printed with your name and telephone number.

Design a brochure to show actual drawings of a variety of house styles. Key information should include media, suggestions for use, your full name, address and telephone number, cost (see "Pricing Your Custom House Portraits," page 109), size and the amount of time you need to be able to produce the house portrait. Duplicate your brochure at a fast-print shop.

My four-page, single-fold bro-

Business Card

H.J. Haberstroh

123 Lane Side St. Bittycity, OH 11577
(800) 555-0000

chure is 5½" × 8½" (14cm × 22cm). It fits nicely into a standard 9" × 6" (23cm × 15cm) envelope along with an invoice or a custom-made gift certificate.

Place a free supply of cards and brochures in a prominent spot at sidewalk art shows. Enclose them with every house portrait you complete, and offer to mail one to every inquiry you receive. Protect them in plastic zipper bags. Keep them in your car, at your job, at school, in your purse and/or your briefcase to give away at a moment's notice.

TIP
for Samples

Short on examples of your artwork? Draw your own home or those of your relatives and friends for free at first to build a portfolio.

HOMES by HELEN
Custom Home Portraits

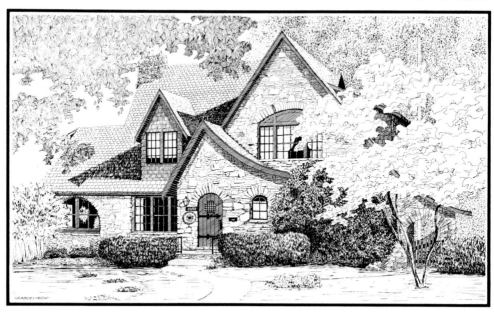

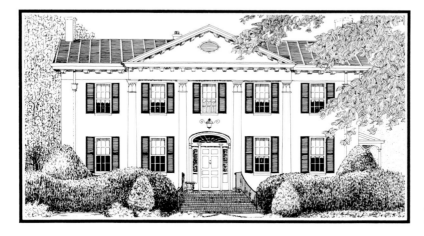

HOMES by HELEN
123 Lane Side Street
Bittycity, Ohio 11577
(800) 555-0000

Custom notepaper featuring the home is available and may include such additional copy as a holiday greeting or a street address.

An economical alternative to a second original drawing of one home is to have one or more prints made from the original drawing.

Framing is an additional cost, depending upon the size and molding style.

Page 4 or back cover

A HOME by HELEN is a custom home portrait drawn in pen and ink, matted and protected by transparent plastic film. It is original artwork that captures a view not always possible in a photograph.

The cost of a pen and ink home portrait varies according to the size of the drawing and complexity of detail. A firm price is given following actual viewing of the home. Quotes based on photographs can also be given.

Placing two or more homes on one page incurs additional customizing effort and adds to the cost.

Holidays, anniversaries, birthdays are family occasions for a unique gift which conveys a special meaning. A custom home portrait can also commemorate ties with friends, neighbors and business associates.

Page 2

Adding watercolor to the pen and ink home portrait also adds to the cost and must be known at the time the work is commissioned.

Scheduling a custom home portrait takes six months to a year depending upon when it is ordered. Please call Helen (800) 555-0000 for timing.

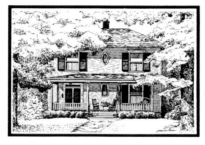

Photographs taken by the artist in the Greater Cincinnati area provide the basis for a Home by Helen.

For out-of-state homes, clients are asked to provide photographs that include details critical to the design of a custom home portrait.

Page 3

Display at a Sidewalk Art Show

Local service groups, women's clubs and professional business guilds often raise money or enterprise awareness by sponsoring one-day sidewalk art/craft shows. Go to one and ask about applications. This is basic retailing and an entertaining way to present work to the public. You pay a small fee for the privilege of:

- Sitting in the sun or rain for eight hours on a 10′ × 10′ patch of cement
- Hauling and setting up your display of portraits (often borrowed back from clients)
- Smiling incessantly
- Answering questions
- Hoping someone will ask you to draw a house (someone will, trust me)

Visit a Local Real Estate Office

Ask the manager to hang your framed original house portrait in the office. Attach your business card to the front and await calls. Send the manager a thank-you note enclosing your brochure and business card, whether or not your picture is accepted.

Get Media Exposure

Getting your name and picture in print helps sales. Calling your local newspaper about upcoming shows or awards won gets your name known and adds credibility. Be creative in how to get your name and art good press coverage as often as you can. And remember: The public has short memories—so *often* is the key word.

Donate to a Charity Auction

Donate a gift certificate for an original house portrait to a charity raffle sponsored by a school, club or your public television station. Make available a matted or framed sample.

Pricing Your Custom House Portraits

Pricing is more a function of what the customer is willing to spend than the number of hours required for you to draw and/or paint it. Here are a few guidelines:

- Realtors have an allowable tax deduction for client gifts, which in my area is around minimum wage times five (hours).
- If you are a student hoping to pick up some spending money through painting or drawing house portraits, try pricing based on six hours work at minimum wage, regardless of how much time you really take.

CAUTION

Permission was sought and granted from the owner of each home illustrated in the brochure. Not all that were asked were willing, but all were pleased that I called.

Presenting Finished Work to the Client

Complete your commissioned work by presenting it attractively as well as providing for its protection until framing. Mat the completed house portrait. Add a backing board showing your name, address and phone number. Cover the front with tape-secured plastic wrap. Enclose the whole package with brown wrapping paper and tape it with masking tape. Prepare an invoice showing your name and address, the customer's name and address, amount due for the portrait, tax and total. Presentation is very important.

Make an appointment with the client for delivery to the home or business and advise amount of payment due. Present the invoice to the client in an envelope containing a brochure only after the house portrait has been closely examined and approved. Keep a copy of the invoice for your records.

HELPFUL HINT
for Raising Prices

When the volume of your business increases to the point that you are stressed for time, raise your prices. The law of supply and demand really works.

Invoice

INVOICE

Helen J. Haberstroh
123 Lane Side Street
Bittycity, OH 11577
(800) 555-0000

Terms: Net upon presentation of invoice.
Make checks payable to Homes by Helen.

Sold To	Date
Mrs. John Doe	March 1, 2001
835 Street Side Lane	
Bittycity, OH 11577	

Custom Pen & Ink Home Portrait	$200.00
Framing	
Prints	
Subtotal	$200.00
Ohio State Sales Tax	$12.00
Shipping & Handling	
Total Order	$212.00
Less Deposit	
Amount Due	**$212.00**

Enjoy Your Clients' Satisfaction

Your clients have no inkling about how your finished artwork looks. Feed their excitement by letting them open the package you have brought. Stand back quietly and watch their faces break into smiles. What an ego booster for the artist!

PAPERWORK IS GOOD BUSINESS

Not only does it keep you organized, but it also keeps the government happy. It also keeps track of your client base for thank-you notes or upcoming events announcements.

Get the Proper Vendor's License

You will probably need a state vendor's license, which allows you tax-exempt status for purchases of paper, glass and frame used for the house portrait. One perk of having a vendor's license is that it facilitates your setting up accounts with art suppliers advertised in artists' magazines. These are good sources of quality materials at prices discounted from retail.

Financial Pages

Certain records impact your income taxes at the end of each year. On separate pages, record income; cost of materials sold, such as paper and mat board in each sales transaction (keep receipts); cost of materials used, such as ink, pens, brushes, paint, etc.; cost of equipment, such as drawing table, special lights, T-square and rulers. Part of your own home may be tax deductible if it is used solely for your business. If you are totally lost, consult an accountant.

CAUTION

You are required to pay state sales tax on all artwork sold. You may collect that tax from your client.

Maintain a File for Each Client

Making and keeping a retrievable record for each client has given me the resources to develop a brochure and to compile a loose-leaf "brag book" of different styles of houses to show prospective clients. Keep in each client's folder: client information form, photos of the house, a copy of the client contract, and a photocopy of each finished house portrait. Use a metal or cardboard file drawer to store completed work folders.

Client Contract

NAME _____

ADDRESS _____

Home Phone _____ Source _____

Work Phone _____ _____

Date _____

Commission Address _____

Date Needed _____ Conditions _____

Drawing Size _____ _____

COST
WC BW _____
NOTE _____
PRINT _____
Total _____
+6% _____
Shp/Hnd _____
TOTAL

FRAME
Type _____
Size _____
Price _____

Address _____

Directions _____

NOTEPAPER
Number_____PRICE_____
Message on_____(#)
PRINTS
Number_____@$____PRICE_____

Size ____
Reduce to _
%
—

Size ____
Reduce to _
%
—

Windows: 2nd Fl. _____

1rst Fl. _____

Notes _____

Approx. Size (and scale) _____ Drawing Size _____

Add border for paper + _____ Mat Border _____

Paper size _____ Total matted size _____

Paper brand _____ Cut Mylar Cover _____

DATE	EVENT	TIME	MILE

Organize and Maintain Business Aids

Arrange these general aids into a three-ring binder: client listing, commissioned work schedule for the year and financial pages.

Client Information

OMES by ELEN

Helen J. Haberstroh
123 Lane Side Street
Bittycity, OH 11577
(800) 555-0000

November 5, 2000

Mrs. John Doe
594 Street Side Lane
Bittycity, OH 11577

Dear Mary,

Personalize this paragraph.

I enjoyed meeting you this fall at the Mt. Adams Art Show and look forward to providing a custom house portrait of your mother-in-law's home, soon to be vacated. With the tree leaves down, I was able to get good pictures of the whole house. Later I'll prune the branches that obscure some of those exquisite eaves brackets and other Victorian ornamentation.

Pricing below of a pen and ink drawing is based on size and complexity of details, both architecturally and in the landscaping. The completed picture will be matted but not framed. Approximate framed size is shown to suggest the space it will occupy, but framing is not included in the price. Framing can be provided at additional cost.

Drawing Size (width x height)	Price Black & White	Add Water-color for Total	Approximate Framed Size
10" x 4.5" (small)	$150	$200	15" x 9.5"
12" x 6" (medium)	$200	$300	18" x 12"

Will you please call me at your earliest convenience with your decision on size and whether you want the watercolor added?

As you know from our earlier conversation, this work is on my schedule for February, 2001 which will make it available early in March when your Mother-in-law has moved to her apartment.

Timing commitment

Thanks for your confidence in my work. I look forward to providing this special memento of a home long loved with many memories.

Sincerely,

Helen J. Haberstroh
Artist/Owner
Homes by Helen
(800) 555-0000

CLIENT LISTING - 2000

NO	DATE IN	NAME	SHOW OR SOURCE	PRICE	BW OR WC	DATE PAID
1	1/3/0	GRANT	HABERSTROH	$250	WC	
2	1/17/0	CROCKETT, D.	YELLOW PAGES	$275	WC	
3	2/11/0	HABERSTROH, DR.	HABERSTROH	$175	BW	
4	3/1/0	HABERSTROH, D.	YELLOW PAGES	$125	BW	
5	5/9/0	SEXAUER	MADEIRA SHOW	$250	WC	
6	5/10/0	LEONARD, M.	YELLOW PAGES	$175	BW	
7	6/2/0	DRACHMAN, R.	HABERSTROH	$225	WC	
8	6/6/0	WHALEN	LEONARD	$350	WC	
9	7/1/0	HABERSTROH, R	YELLOW PAGES	$450	WC	
10	9/9/0	LEONARD, T.	LEONARD	$150	BW	
11	9/17/0	DRACHMAN, E.	MONTGOMERY SHOW	$300	WC	
12	9/24/0	JOHNSON, E.	WEST. HILLS SHOW	$250	WC	
13	10/1/0	CROCKETT, C.	HYDE PARK SHOW	$200	WC	
14						

SCHEDULE FOR YEAR 2000

MONTH	WEEK 1	WEEK 2	WEEK 3	WEEK 4	WEEK 5 A
JANUARY	VACATION	GRANT			X X X
FEBRUARY	CROCKETT		DOE		X X X
MARCH	VACATION		HABER	DR	
APRIL	HABER D			SHOW PREP	X X X
MAY	ART SHOW	SEXAUER		LEONARD	
JUNE	DRACHMAN		WHALEN		
JULY	HABER R	VACATION		HABER R	X X X
AUGUST					
SEPTEMBER	SHOW PREP	SHOW PREP	SHOW PREP	LEONARD T	X X X
OCTOBER	LEONARD T		DRACH. E	CHRISTMAS	CARDS
NOVEMBER	DRACH. E	JOHNSON		CROCKETT C	
DECEMBER				X X	X X X
JAN. 01					

USING PORTRAITS OF BUILDINGS IN OTHER WAYS

The single house or church portrait, reduced in size, may generate other income-producing ideas, such as notecards, prints and program covers. Questions posed by clients become challenges to be met and implemented, opening a rich new world of print processes and paper choices, as well as a large secondary source of sales.

Church commissions of the original drawing can lead to notecards, Sunday worship bulletins and marriage and memorial service program covers. Large, long-established churches have agreed to my proposal to make prints and sell them at shows where local members become customers. Those prints also make appropriate gifts for staff members who leave that employment. Just recently, a church honored its most elderly members with framed black-and-white prints during Senior Citizen Month.

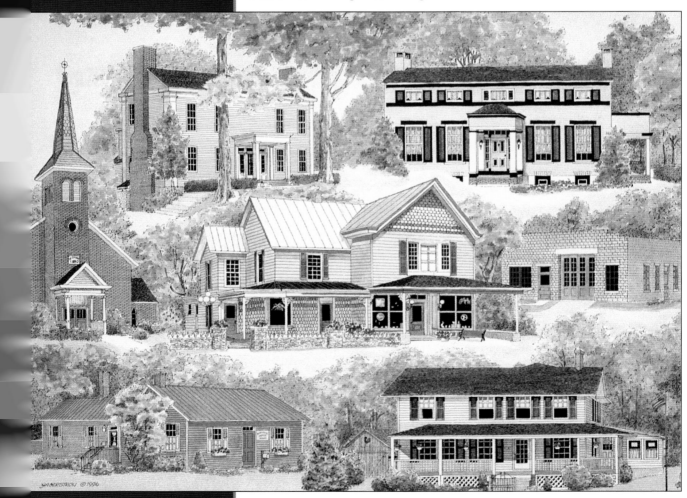

INCOME-PRODUCING IDEAS

Combining the photographic reduction of an original pen-and-ink drawing with a metal printing plate provides the basis for notecards, postcards and prints. While more expensive than reduction by even the best commercial copier, a metal plate captures the clarity of every ink line of the original. Choose high-quality paper, which comes in a wide variety of weights and colors.

Take the original pen-and-ink drawing to several small-sized local printers and ask them specifically about their photographic reduction and "paper" and metal plate printing process. Also ask if they will print such small quantities as one-hundred notecards or ten prints of houses. Other questions are cost and time for printing once the artwork is given to them.

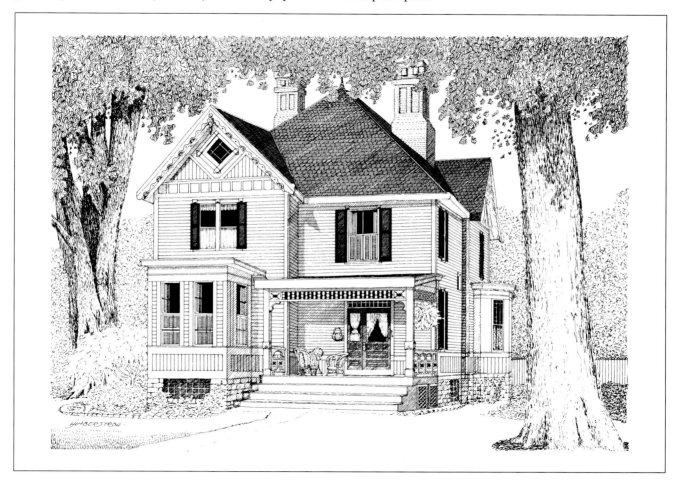

TIP
for Notecards

Smaller size notecards cost less. Single-fold notecards measuring 5½" × 4¼" (14cm × 11cm) fit in standard A-2 envelopes. One sheet of standard paper can be used for two cards. I sell this size depicting local scenes at shows in packages of twelve. Plastic zipper sandwich bags are a perfect size for packaging and much more practical than ordering five hundred custom boxes, which lasted me eight years.

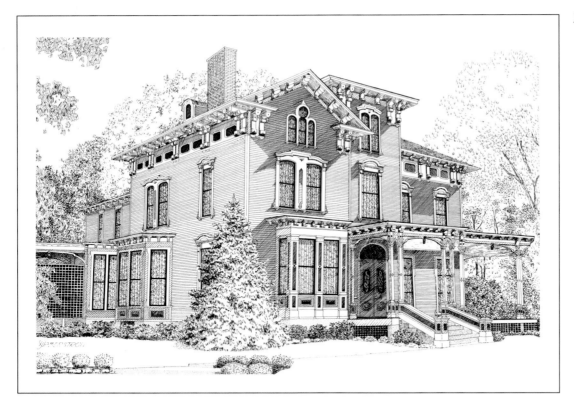

Notecards

Variations on the notecard theme range from serving as simple correspondence to printing the inside with an open-house invitation, seasonal greetings—even to validating the historic significance of the house pictured.

Single-fold notecards measuring 6¼″ × 4½″ (16cm × 11cm) fit nicely into standard A-6 envelopes, which can be ordered from the printer in bulk quantities. Sizing postcards for minimum postage and certain delivery requires a telephone call or visit to your local post office for the rules that govern this service. Pricing notecards depends on their size and quantity and should be in line with the prices of other notecards you see for sale.

Prints

To size prints of house portraits, reduce the original to fit on standard 8½″ × 11″ (22cm × 28cm) paper with about ½″ to 1″ (1cm to 3cm) margin all around. When siblings order a house portrait for their parents' anniversary, they are often delighted to learn that prints of this, their childhood home, can be made available very economically. When printed on vellum (smooth velvet) finish 80-lb. (170gsm) paper, they can even be painted with watercolor similar to the original.

Calendars

Calendars as year-end gifts from my printer to faithful customers were a collaborative effort for a number of years. Prints of historic homes ordered by my clients illustrated each month in one edition, after I secured the clients' verbal and written permission for this public use of their commissioned work. To simplify the written approval process, I sent each a form to be mailed back to me in a self-addressed stamped envelope. Each of those clients received a complimentary calendar. Historic public buildings drawn on my initiative were used another year and did not need owner permission. Extra calendars were available for sale.

Helen J. Haberstroh
123 Lane Side St.
Bitttycity, OH 11577

RELEASE FOR REPRODUCTION RIGHTS

This grants exclusive permission to the artist, Helen J. Haberstroh, of

HOMES by HELEN
123 Lane Side Street
Bittycity, OH 11577

to reproduce her original pen & ink drawings
of the homes at
(address)
for the sole purpose of
inclusion in a 2001 calendar of "Historic Homes"
produced by The Printing Place in collaboration with the artist.

At no time and in no place is the owner or street address identified.
This calendar is to be distributed as a complimentary gift to past and potential clients of The Printing Place and to the owner of the original drawings. A limited number will be available for sale by the artist.

_____ _____
Owner's Name Date

_____ _____
Helen J. Haberstroh Date
Artist/Owner

**Please sign and return this form
in the enclosed self-addressed stamped envelope**

☐ Please send me ____additional Calendars @$10 (includes tax, shipping/handling).
(Bill will be mailed when Calendars are shipped in late fall, 2001hjh)

Handy Tool for Resizing

A plastic, circular proportion scale tells you what percentage of the original size is your desired larger or smaller size. This is available at any drafting supplies store. I use it to test my dimensions on a commercial copier before taking work to a printer.

TIP
for Black-and-White Printing

If the house portrait is to be finished in color, make a full-size copy of the pen-and-ink image before watercolor is added. Complete the texture and shading with pen and ink on the copy and use that as the original for black-and-white printing.

BRANCHING OUT TO OTHER SUBJECTS

Historic Structures

The innate charm of intricately designed and colorful historic structures continues to appeal to me and these works sell well locally. For example, long-established restaurants in remodeled historic buildings appeal to young and old alike for traditions remembered.

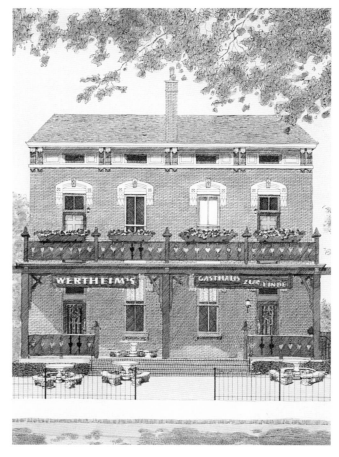

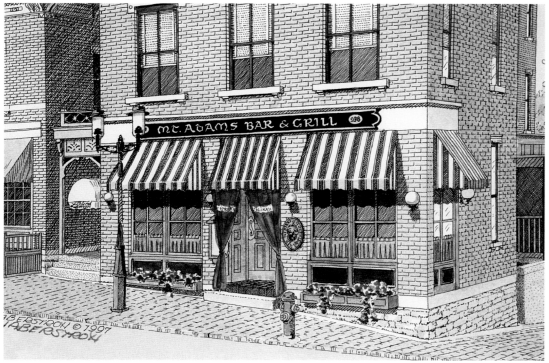

Foreign Travel Opportunities

When foreign travel opportunities beckon, castles, charming streets and quaint flower-bedecked facades beg to be drawn. The pages in my 6″ × 9″ (15cm × 23cm) spiral-bound sketchbook are quickly covered with black ballpoint pen drawings that later appear on notecards and prints available for sale to fellow tourists and the general public.

Katz Castle, St Goarshausen Rhine River

Local City Centers

Local city centers where I participate in sidewalk art shows are now appearing on my print and notecard offerings at all shows. Each print is reduced to 4″ × 6″ (10cm × 15cm), individually painted with watercolor and secured to an 8″ × 10″ (20cm × 25cm) mat. Notecards are single-fold, measure 4¼″ × 5½″ (11cm × 14cm) and fit a standard envelope size (A-2).

Pavilion Street–Mt Adams

Composite Portraits

Combining pictures of several homes meets the need of the client to record each of those special chapters in the life of that family. Take time to arrange the houses on the page in an aesthetically pleasing way.

Involve your client in designing the placement of the views. Make small in-scale sketches of each home that can be moved around to demonstrate several views. The owner may logically want first, second and third house in order on the paper, but that arrangement may not produce an artistic flow of one to another. You may need all of your diplomacy skills to reach a compromise if your way is not immediately accepted. Remember: The owner is paying for this.

Picturesque historic neighborhoods are good subjects for composite prints and have found an appreciative audience at shows and galleries. Variations on composite and connected themes include those pictured here.

Repeat Customer's Homes

First home

Second home

Third home

INDEX

Groundline, 57

Half-timber siding, 73-74
Historic neighborhoods, 125
Historic structures, 120-121
Home business, 104-115. See also Business
Horizontal lines, 31, 57
House numbers, 21
House portraits
 adding sparkle to, 54
 aesthetic center of, 48
 artwork samples, 106
 composite, 125
 home business, 104-115
 long horizontal homes, 22
 other uses for, 116-119
 photographic model for, 16. See also Reference photos

Income-producing ideas
 calendars, 119
 notecards, 117-118
 prints, 119
Ink
 erasers for, 13
 waterproof black India, 13
Inking
 brick, 32
 details, 33
 foliage, 30
 freehand, 30-32, 61
 horizontal lines, 31
 inner details, 36
 landscaping, 34-35
 long beams, 74
 louvers, 81
 outlines, 36
 procedure for, 30-34
 roof area, 32
 shadows, 33, 74
 shingled siding, 62
 siding, 32
 stones, 70
 vertical lines, 30
 for watercolor, 41
Invoice, 110

Landscaping
 drawing, 29
 finishing, 54
 hiding house, 26
 inking, 34-35
 painting, 44
 photo of, 21
 planning, 38
 unclear details in photo, 11
 See also Bushes; Foliage; Trees
Light fixtures, 21
Lighting, 18-19
Linear perspective
 angles with, 56
 realism and, 62

sight-judgment method, 58-59
 technical side of, 57
Lines
 diagonal, 37
 horizontal, 31, 57
 straight, 37, 97
 vertical, 30
Local city centers, 124

Magnifying glass, 11, 27
Marketing
 brochure, 106-108
 business card, 106
 charity auction, 109
 media exposure, 109
 pricing, 109
 promotion, 106
 real estate offices, 109
 sidewalk art show, 109
Masking fluid, 15, 43
Masking tape, 41
Media exposure, 109
Medicine dropper, 14
Mulching, 45
Mullions
 on casement windows, 78
 defined, 26
 dividing space for, 27
 on double-hung sash windows, 76-77

Notecards
 drawings on, 116
 local city centers, 124
 pricing, 118
 single-fold, 118
 tip for, 117

Paint
 palette colors, 14
 student grade, 13
 watercolor, 13
Painting
 background, 42, 53
 brick siding, 43, 46
 bushes, 43
 details, 46
 driveway, 45
 flowers, 52
 foliage, 50, 52
 grass, 42
 roof, 43, 51
 shadows, 47
 siding, 51
 trees, 42, 45
Painting over, 54
Palette
 basic colors, 14
 cover for, 14
 mixing, 41
Paper
 acid-free bristol, 12
 good, 10

kid, 12
 painting on dry, 49
 for pen and ink, 12
 plate finish, 12
 scrap, 42
 testing colors on, 42
 vellum finish, 12
 watercolor, 13, 80
 width of, 25
Paper towel, 15, 41, 49
Peak
 decorative, 99
 of roof, 58
 siding on, 59
Pen & ink
 demonstrations, 25-35, 36-39
 paper for, 12
 with watercolor, 40-55
 See also Inking
Pencil
 drawing grid in, 62
 erasing guidelines, 41
 hard lead, 12
 horizontal guidelines in, 33
Pens
 0.25mm, 13, 30
 0.50mm, 13, 33
 ballpoint, 11, 25
 cleaning, 13
 Koh-I-Noor Rapidograph technical, 13
 nib sizes, 13
 no. 1 drawing, 47
 storing, 13
Perspective
 linear. See Linear perspective
 two-point, 57
Photos
 clients', 17
 close-ups, 11, 17
 of details, 21
 developing film for, 22
 enlarging, 11
 finish for, 22
 measuring elements in, 24
 notes about, 22
 reference, 11, 25, 48. See also Photos, taking
 regular size prints, 22
 tape residue on, 11
 trees in, 20-21
Photos, taking, 17-23
 choosing view, 18
 conditions for, 17
 lighting and, 18-19
Picket fence, 103
Pillars, 21
Porches, 100-101
 railings, 21, 102
 wrought iron support, 101
Pricing
 house portrait, 109-110
 notecards, 118